Products of our Time
David Redhead

'Index of Desire' is an artists' project sampling search words keyed into an internet search engine over a twenty-four hour period. The text running along the bottom of the pages of this book forms a separate project made for *Products of our Time* named 'Sliver', representing 16 minutes and 36 seconds from the complete Index. It reproduces the search words exactly as they were keyed in by internet users. *'Sliver'. 18.10.99, 10.23pm – 18.10.99, 10.39pm. Neil Cummings, Marysia Lewandowska, Geoffrey Makstutis and Jason Pidd.*

ok' icon cards - Dictnary - Pikacu's quest - ben harper tabs -

A CIP catalogue record for this book is available from the Library of Congress, Washington DC., USA

Deutsche Bibliothek Cataloging-in-Publication Data

Products of our time / David Redhead - Basel ; Boston ; Berlin : Birkhäuser ; London : August Media, 2000

✓ ISBN 3-7643-6234-0 (Basel...)
ISBN 3-7643-6234-0 (Boston)

© 2000 Birkhäuser - Publishers for Architecture, PO Box 133, CH-4010 Basel, Switzerland.
August Media Ltd, 116-120 Golden Lane, London EC1Y 0TL, UK.

Printed on acid-free paper produced from chlorine-free pulp. TCF ∞

ISBN 3-7643-6234-0
ISBN 3-7643-6234-0

9 8 7 6 5 4 3 2 1

Publishing director: Nick Barley
Art director: Stephen Coates
Editorial team: David Redhead, with Nick Barley, Stephen Coates, Hannah Ford, Ally Ireson and Alex Stetter

Production co-ordinated by: Uwe Kraus GmbH
Printed in Italy

Author's acknowledgements
For Sara.

My particular thanks are due to Jayne Alexander, Violetta Boxill, Tim Brown, Julian Ellison, Chelsey Fox, Anne Gardener, Geoff Hollington, Melanie Howard, Ian Redhead, Mark Redhead, Richard Seymour and Terence Woodgate for their help and inspiration.

Acknowledgements
The publishers would like to thank the following:
Blueprint, Nicole Bellamy, Stanley Bloom, Fiona Bradley, Sebastian Coates, Diana Eggenschwiler, Damian Horner, Bettina von Kaneke, Werner Handschin, Nigel Jackson, Jessica Lack, Stuart Martin, Julia Morlock, Anne Odling-Smee, Elisabeth Scheder-Bieschin, Deyan Sudjic, Robert Steiger, Margarete Stetter, Veronika Stetter, Paul Weston.
'Sliver': Special thanks to Positive Internet Company Ltd, London for technical consultancy and web hosting.

Glasgow 1999
UK City of Architecture and Design

aol tricks - microcomputer theory - web design arrows - asian rope bondage - summit point racing - Breadner Computer - Eastern

David Redhead

PRODUCTS
OF OUR
TIME

Birkhäuser -
Publishers for Architecture
BASEL · BOSTON · BERLIN

August LONDON

Pilots versus Continental Airlines - +"wavs" +"abbott & costello" - restless legs - "May Wong" - diabetic diets - monitor filters -

Contents

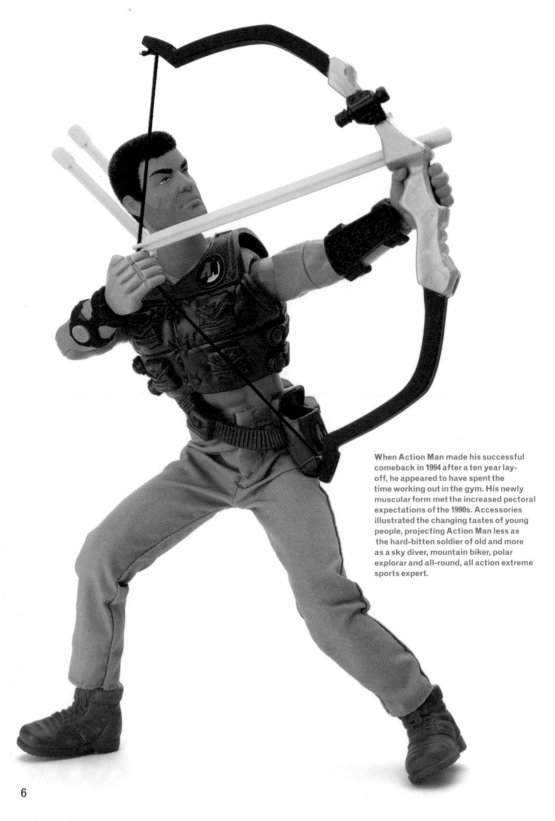

When Action Man made his successful comeback in 1994 after a ten year lay-off, he appeared to have spent the time working out in the gym. His newly muscular form met the increased pectoral expectations of the 1990s. Accessories illustrated the changing tastes of young people, projecting Action Man less as the hard-bitten soldier of old and more as a sky diver, mountain biker, polar explorar and all-round, all action extreme sports expert.

nes rom hundreds - celebrity babes - mainship - limp bizkit - hummingbirds - volleyball and setting - +female hockey +edmonton -

Preface

What makes the subject of design such a fascinating one is that it is not simply an economic issue, or a means of self-expression. It is both about culture, and about commerce. That was an underlying theme of Glasgow's year in 1999 as UK City of Architecture and Design. And it is this duality which makes design a powerful focus for looking at where the world is going. The objects that we make, the way that we design them, the meanings that we invest in them, give design a significance way beyond pragmatic production methods, or simple utilitarian functionalism.

David Redhead's exhibition at The Lighthouse in Glasgow, which provides the starting point for this book, demonstrates that brilliantly. It looks at the torrent of new possessions we all have, and attempts to make sense of them, from fashion to digital technology. It has made its selection not on the basis of excellence in design, but on the basis of relevance.

It is both a history of the recent past, and it is a map charting the directions that we are likely to take over the years to come. It captures the tumultuous changes that society has gone through in the 1990s as witnessed by its technology, its taste, and its efforts to make objects that promise a means of domestication, and taming all that change.

It is not always comfortable, or a flattering portrait of a decade. It reveals the trivial as well as the profound, the sinister as well as the worthy. But that, of course, is the point of any effective portrait.

Deyan Sudjic
Director, Glasgow 1999: UK City of Architecture and Design

Introduction

Histories of design tend to fall into two categories. They are either collections of EXCLUSIVE CULT OBJECTS which most people cannot afford to buy, or round-ups of intellectual movements which are read mainly by academics. When I was first asked to write a book and curate an exhibition about design in the 1990s I was quite clear that *Products of our Time* would not fit so neatly into either pigeonhole.

Design has never touched more aspects of our lives than it does now. It speaks to us of haute couture, of INNOVATION, CREATIVITY and BUSINESS SUCCESS, of Cool Britannia and of the *Wallpaper** lifestyle. But while it touches on all these things, design's currency and relevance is much broader than that.

It is tempting to think of design history as a record of what we do to objects, forgetting that the objects are also a record of us. Design means most of the things that surround us: the things we WORK, PLAY, DREAM with; the tools with which we strive to master new challenges; the fabric of the world we have built. Just as

we, the MILLENNIAL GENERATION, are products of our time, so the shape and character of our products reflects the preoccupations of our generation.

This idea of looking at objects 'from the other end of the telescope' was the starting point both for *Products of our Time* and the Glasgow 1999 exhibition, 'Identity Crisis', which inspired it. The aim was to create an instant cultural history from things that surround us now; the challenge to find ORDINARY and EXTRAORDINARY objects which had a resonance for many, if not all, of us; the plan to group them into themes that people recognised and found familiar.

Since this was intended as a history in objects, the objects were where our research began. We spent half of 1998 and most of 1999 trawling NEWSPAPERS, MAGAZINES, SHOPS and EXHIBITIONS for 'products of our times'. The definition of products was broad, the criteria for inclusion in the exhibition and book, simple. They included THREE-DIMENSIONAL OBJECTS, VIRTUAL IMAGES, INTERIORS, PACKAGING and GRAPHICS, all made during the 1990s, all of which in some way

sex - united states of america - Firts Year Seminar - wheel of fortune - nookie.com - ladybumps - tapeworm - nudewives - film history

We design them. They illustrate us.

Technology has opened up possibilities which stretch beyond anything we could have dreamt of ten years ago. The AIBO Entertainment Robot (right) produced by the Sony Corporation is predicted to be the first of the new age of virtual pets aimed at adults, a craze which began with toys such as Tamagotchi and Furby.

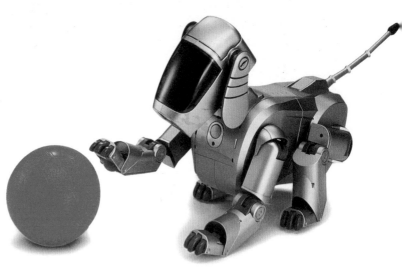

seemed to catch the spirit of the times.

The research threw up plenty of STRANGE and INTERESTING things. The challenge was to draw out of them a view of the times which rang true as well as feeling coherent. Initially this goal seemed ambitious. But the more products that we gathered for 'Identity Crisis', the stronger the patterns within them became. These crystallized out into the five chapters that make up *Products of our Time*.

Each of these considers a distinctly 1990s theme through a collection of products: Basics investigates our pre-millennial desire for simplicity; More examines the implications of the extraordinary consumer choice the era has brought with it; Control considers humankind's growing sense of technology-driven autonomy; Identity looks at the evolving struggle for a sense of self; Crisis studies contemporary visions of progress.

Initially, these chapters seemed to contain internal CONTRADICTIONS and IRONIES. Yet as we amassed more products it became clear that the

contradictions could be considered a strength rather than a weakness, reflecting an experience of the modern world that many of us share.

In technological terms, the past ten years have been some of the most action-packed of the century and have brought extraordinary change – at least to the so-called developed world. Almost overnight, new industries – the INTERNET and BIOTECHNOLOGY, for example – have become big business. The digital revolution has continued to transform the process of PRODUCTION and of COMMUNICATION. Thanks to the World Wide Web, to a fast-growing minority, the global village already feels like a reality.

Yet a decade that has seen such technological p r o g r e s s has also brought into question our vision of what progress means. We live in times that are as confusing as they are exciting. We mistrust 'isms' – Modernism, Communism, Thatcherism all seem to have gone by the wayside and we're reserving judgment on BLAIRISM and the THIRD WAY.

- crystal radio works rf theory - susan b koamon race - Hajime+Soroyama+pinups - Hacking information learning - horoscopes -

Ours is the ambivalent generation, the generation that questions everything and accepts nothing

We are sceptics because we've learnt from experience that it pays to be that way. In our millennial era, no sooner have we accustomed ourselves to the idea of the world working in one way than a new moral dilemma or unexpected variable comes along to dynamite our assumptions. The list seems almost endless. How do we reconcile our new PRODUCTIVITY with the need for SUSTAINABILITY? Our GLOBALISM with resurgent NATIONALISM? Our improving health with the global plagues that surround us? Our taste for the futuristic with a nostalgic appetite for the past? This is a world which increasingly seems to defy our attempts either to make sense or impose order. In today's techno-capitalist society, ECONOMIC, POLITICAL and ETHICAL absolutes seem implausible, easy solutions unthinkable.

This is the story we have told in *Products of our Time* and 'Identity Crisis'. But the book and exhibition are intended not only as a record of the 1990s in objects but also as an insight into the way design can help make sense of our world. *Products of our Time* makes images central to its arguments. In our consumerist age, plenty of practice has made us expert at editing the information we receive from the PRODUCTS, OBJECTS and VISUAL MEDIA that surround us. But we usually read each message in isolation, rarely attempting to fit them into a pattern or a whole.

Yet in a media-saturated world, the images that surround us are becoming almost as much of a communication currency as the written word. If the design that surrounds us reflects the way we are, then we need to become more rigorous in the way we read its meaning. This book argues that by looking harder at design we can get a deeper grasp of the way that the world is shaping up for the third millennium.

Of course, analysing the products of our time is likely to pose as many questions as it answers. But it is by studying the things that surround us in depth that we give ourselves the chance of making the products of our time – ourselves included – better.

1. Basics

A style for the 1990s

Bearing in mind the sleaze that followed, John Major's pledge to take the business of government 'Back to Basics' was one of the great political own goals of the decade. But for once Britain's Conservative Prime Minister did almost seem to catch the public mood. In the early 1990s simplicity felt like a natural antidote to the era of conspicuous consumption that preceded it. And, if style and design are any sort of metaphor for the wider world, our craving for a bit more clarity in our lives remains as urgent as ever. Trends may come and go but the quest for simplicity ⟫→

"I think that many people, particularly those of you who are older, see things around you in the streets and on your television screens which are profoundly disturbing. We live in a world that sometimes seems to be changing too fast for comfort. Old certainties crumbling. Traditional values falling away. People are bewildered. Week after week, month after month, they see a tax on the very pillars of our society – the Church, the Law, even the Monarchy, as if 41 years of dedicated service was not enough. And people ask, "Where's it going? Why has it happened". And above all, "How can we stop it?"

Let me tell you what I believe. For two generations, too many people have been belittling the things that made this country. We've allowed things to happen that we should never have tolerated. We have listened too often and too long to people whose ideas are light years away from common sense.

In housing, in the '50s and '60s, we pulled down the terraces, destroyed whole communities and replaced them with tower blocks and we built walkways that have become rat runs for muggers. That was the fashionable opinion, fashionable but wrong. In our schools we did

away with traditional subjects – grammar, spelling, tables – and also with the old ways of teaching them. Fashionable, but wrong. Some said the family was out of date, far better rely on the council and social workers than family and friends. I passionately believe that was wrong.

Others told us that every criminal needed treatment, not punishment. Criminal behaviour was society's fault, not the individual's. Fashionable, but wrong, wrong, wrong.

On all these things, with the wisdom of hindsight, received opinion was wrong. And now, we must have the courage to

stand up and say so and I believe that millions of people are longing to hear it.

Do you know, the truth is, much as things have changed on the surface, underneath we're still the same people. The old values – neighbourliness, decency, courtesy – they're still alive, they're still the best of Britain. They haven't changed, and yet somehow people feel embarrassed by them. Madam President, we shouldn't be. Madam President, I believe that what this country needs is not less Conservatism, it's more Conservatism of the traditional kind that made us join this party."

liver cleanse - classroom rules - Halloween candy - capital asset pricing model - internet hoaxes - colacion - kentucky state - Tommy

"It is time to return to those old core values, time to get back to basics, to self-discipline and respect for the Law, to consideration for others, to accepting responsibility for yourself and your family and not shuffling off on other people and the state."

Extract from John Major's speech to the Conservative Party Conference 1993. Courtesy the Office of The Rt Hon John Major MP

Michael Marriott's 'XL1' kit chair, his 1993
Royal College of Art graduation project,
was a world away from the glitzy
furniture designs of the 1980s. With a seat
constructed from a recycled tea chest
and shaped like a camping chair, it was
practical and easy to produce but lacked
nothing in personality.

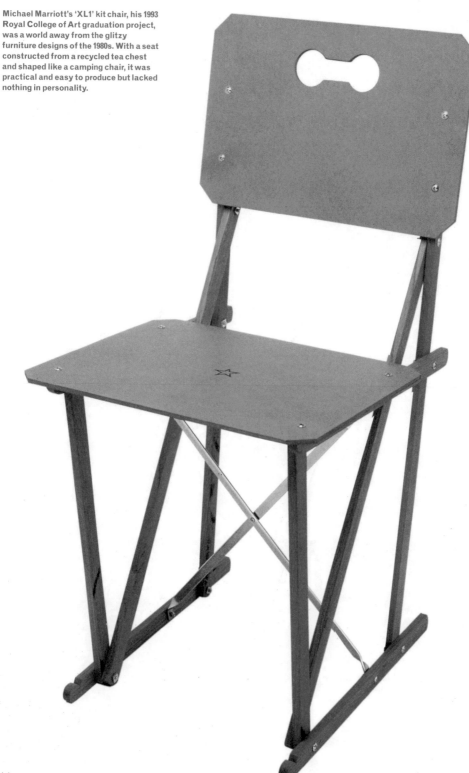

14

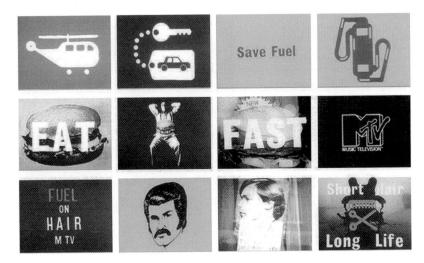

remains both a cultural and a stylistic constant.

Think about it. Ikea, the mass market purveyor of 'flatpack modern' has conquered the UK; the rise of loft living has made 'post-industrial' a lifestyle to aspire to; stores trading in 'basic' fashion and accessories like Muji and Gap have expanded apace. In many parts of Britain, stripped back bars that even the legendary Bauhaus-era modernists might have been happy to frequent have replaced Victorian heritage pubs as the favoured local watering hole.

If any disciples of the Bauhaus are still around, no doubt they would see the new acceptability of the 'less is more'

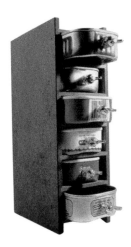

Michael Marriott's fondness for recycling items like sardine cans in this collector's cabinet from 1989 (left) is motivated less by eco-principles than by the desire to add the warmth and personality of familiar objects to his furniture.

Like Marriott, the design collective Fuel pursues a simple aesthetic, but in graphic form. Fuel created an ironic commentary on the vogue for computer generated design with found typography and graphic symbols in a 1993 advertisement for MTV Europe (above).

The trend for simplicity reached its zenith with the craze for loft-style living in cities all over Britain. London's Geffrye Museum has a room devoted to domestic life in the 1990s. It takes the form of a minimally furnished loft (right).

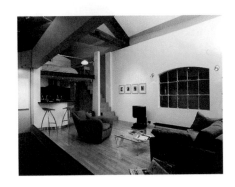

15

Jane Atfield has been experimenting with recycling since the early 1990s. Her 'Made of Waste' furniture (right) is made from plastic bottles, which are washed and chipped and then turned into multi-coloured sheets using heat and pressure. Her chair in industrial felt (below right) is reminiscent an artwork by Joseph Beuys.

The mechanism for the 'Rise 'n' Fall' table (below left) designed by Luke Pearson in 1993 aimed to be as simple as the birch plywood and no-nonsense painted metal T-sections that were used to make it.

mantra as the fulfilment of a long-cherished dream. But when the back to basics impulse gained momentum in Britain at the 1993 Royal College of Art furniture degree show, it hardly seemed like a modernist revival. At a time when the phrase **designer chair** still conjured up the designer decade's palette of crushed velvet, black leather and cast aluminium, the work of these graduates felt like the final sweeping away of all the decadent detritus of an era of excess. Instead of extravagant one-offs, the rising generation was offering inventive production pieces. And wood was the material of choice: laminated, bent, even salvaged. Luke Pearson's

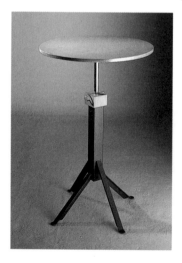

huns - Goldfields - dvd player review - augsburg lechhausen - Sniffit - xxx cartoons - gothic photographs - blaze & blade crack -

plywood Rise 'n' Fall table and Michael Marriott's chair with a seat and back constructed of old packing cases, apparently fresh from the skip, were typical.

It would be unwise to read too much into chairs and tables. In the grand scheme of things they're admittedly a sideshow. Even so, the character of modern furniture and the materials from which it is made are often an accurate barometer of the broader economic and cultural mood. If shiny plastic epitomised the pop culture of the 1960s and matt black leather the flashy decadence of the 1980s, so plywood – PRACTICAL, NO-NONSENSE and BASIC – is as good

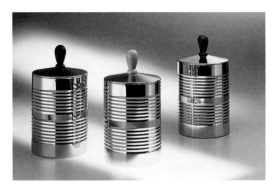

Taking its form from a standard piece of plastic pipe, the 'American Plumbing Vase' (above) is typical of Constantin Boym's approach to the use of found objects. The vase was inspired by Duchamp's remark that "the only works of art America has given the world are her plumbing and her bridges." Boym's 'Tin Man' (left) is a storage container modelled on the grooved form of an old soup tin, stripped of its label. But while the form may be throwaway, the material used to make the container is not. 'Tin Man' is made out of the flawless stainless steel that Alessi imports to Italy from France.

Jasper Morrison's 'Plywood Chair', 1988, (left) formed part of a seminal installation at the Werkstadt in Berlin entitled 'Some new items for the home, part I'. Morrison's approach has found many disciples in the past decade.

a symbol of the early 1990s as any.

This after all was an era that was as gloomy as the late 1980s had seemed vibrant. In the painful recession that followed the Gulf War, a spirit of sobriety was asserting itself in Europe. The Greens were riding high in the political polls, and the British media were full of prophecies of the rebirth of community and family values. High interest rates and the property slump were taking their toll and many people suddenly had no money to spend. Understandably, the prevailing mood seemed to be anti-brand and anti-excess. The furniture that went along with the mood – green, plain,

"Humility is an inevitable step in the cleansing process that has been taking place in design."

Penny Sparke, Professor of Humanities, Royal College of Art, 1993.

18

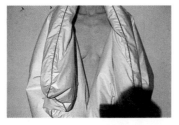

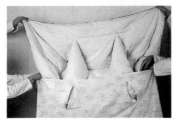

simple, easy to manufacture and useful-looking – felt a bit like design's version of a hair shirt, an atonement for all the shoulder pads and Porsches some had indulged in a few years earlier.

Other design disciplines were going through a similar hand-wringing exercise. Even fashion, hardly the most conscience-stricken of industries, was showing signs of penitence. In 1999, Belgian designer Martin Margiela signed up to revive the image of exclusive French couture house Hermès, although had earlier made his name as something of an anti-brand rebel: his plain-looking greatcoats, overalls

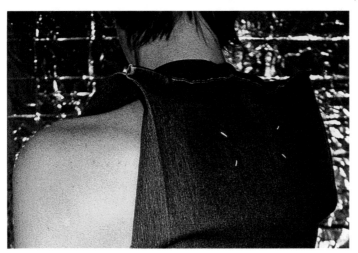

Belgian fashion designer Martin Margiela knowingly undermines fashion's label fetish with a no label label. To those in the know his trademark rough-sewn square of blank white cloth (or even the tiny stitches seen in this garment from his Spring/Summer 1998 collection) is as much a status symbol as the Chanel logo. Ironically, at the end of the 1990s, the Belgian signed up to revive one of the grandest of old labels, Hermès.

Margiela's Duvet coat (above) deconstructs the conventions of couture fashion by using a simple household item as the basis for a garment. The shape of the vest (left) is inspired by a plain brown grocery bag.

Modelled on the classic symbol of the
Red Cross, the medicine cabinet (right)
designed by Thomas Eriksson for the
Progetto Oggetto range by Cappellini in
1992, acts as a simple and witty symbol
of its function as a first aid tool. But the
charity objected to the commercialisation
of its image, so the cruciform cabinet
now comes in any colour but red.

It would be hard to imagine a more
minimal desk than Unifor's Less table
(below right), part of a range by Jean
Nouvel, the king of French high-tech
architects.

and aprons were beautifully cut but it was their studied sense of anonymity – signified by a blank, roughly sewn square of white cloth instead of a logo – that made their elusive designer stand out.

What had begun as an instinctive backlash to 1980s decadence quickly began to acquire all the momentum of a movement. Among Italian design magazines – always the furniture design industry's most vigorous cheerleaders – the new interior trend soon had a NAME; a figurehead in the shape of laconic Englishman Jasper Morrison; and an articulate patron, the Milanese furniture entrepreneur Giulio Cappellini.

'New Functionalism'
'Nuovo Funzionalismo'

"This is not design for art collectors," he declared in 1993 after launching Progetto Oggetto, a collection of "ordinary and not so ordinary" home accessories that showcased the stripped back work of assorted Northern European and British designers. "This is about buying design because you need it."

Utilitarian design with a twist was the coming thing all over Europe. The Dutch collective Droog (meaning 'dry') was providing its own clever take on 'found objects' – like Rody Graumans' chandelier made of 85 naked light bulbs, and Tejo Remy's strapped together chest of drawers. The Germans were injecting a serious-minded sustainable edge; and the Scandinavians – their design output more or less overlooked in the rest of Europe since the 1970s – were getting excited too. Several Swedish companies were busy producing variations on the New Functionalist theme, portraying their 'BASIC, BEAUTIFUL, HUMOROUS, FUN' furniture as a statement of ethical ⫸

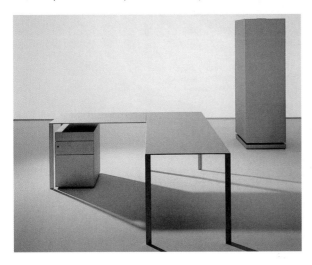

DROOG DESIGN

Droog is a loose association of Dutch designers which caught the attention of furniture designers with an exhibition of products at the Milan Furniture Fair in 1993. Brought together by designer Gijs Bakker and art historian Renny Ramakers, the first collection consisted mainly of objects re-using old materials, including a chest of drawers designed by recent graduate Tejo Remy made from a motley selection of drawers roughly tied with a large belt.

Droog was not the first to advocate a new simplicity in design (Cappellini's Progetto Oggetto had been shown at Milan the previous year), but their debut in the midst of a painful European recession struck a chord with those who felt that designers had become slaves to the exuberant, throw-away culture of consumerism which characterised the boom of the 1980s. Droog's approach turned its back on the notion of design as a style applied to products, concentrating on witty reinventions of ordinary furniture and accessories.

The collective was in the right place at the right time but Droog's subsequent output confirmed its place in the vanguard of the philosophical shift away from excess to a new plainess. Its influence continued to grow: in 1996 Droog was invited by German manufacturer Rosenthal to develop new approaches to the use of porcelain, and in 1997 the Museum of Modern Art in New York included work by Droog designers in its influential 'Mutant Materials' exhibition.

In the same year, Droog exhibited again at Milan with a project entitled 'Dry Tech', which successfully reconciled the low-tech approach taken by many Droog designers with the continuing evolution of high-tech industrial processes. Marcel Wanders' 'Knotted Chair' is one of the best-known pieces to emerge from the project. Made from rope impregnated with epoxy resin and then hung to dry into its eventual shape, the chair is an example of the ideas and processes which have been flexible enough to accommodate changing concerns in Europe. Appropriately, few of Droog's designers have become household names. Nevertheless the group's output has assured it a place among the most influential designers of the 1990s.

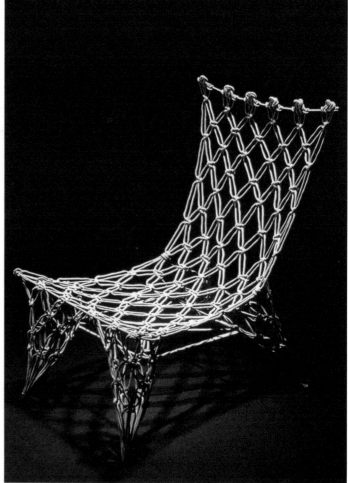

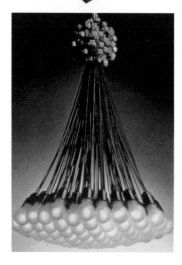

Opposite page, clockwise from top left: 'You can't lay down your memories' chest of drawers by Tejo Remy, 1991; 'Knotted Chair' by Marcel Wanders, 1996 (part of the Dry Tech collection); '85 Lamps' by Rody Graumans, 1993.

This page, clockwise from above: 'The Cross' bench by Richard Hutten, 1994; 'S(h)it on it' bench by Richard Hutten, 1994 (during the showing of these seats in Milan the words "nie wieder" and "never again" were scratched into the bench. These have now become part of the design); 'Kokon' furniture by Konings & Bey, 1997, from the Dry Tech range.

pregnant balloon girl - anti teletubby games - doctors online - Monopoly Deluxe - moveable restaurants - expressionism - Pretty Fly

"A serious and natural reaction against global chaos... the beginning of a global movement."

Designer Tom Hedqvist on New Functionalism, 1993

intent and backing it with portentous <u>statements</u>.

A few hundred furniture designers do not really add up to a global movement and New Functionalism was initially held back by the fact that 'back to basics' products cost much the same as their predecessors. Konstantin Grcic's simple plywood brush-cum-coathanger for Cappellini was priced at well over £100, for example. Haute couture, being the industry it is, Martin Margiela's no brand stance didn't mean bargain fashions either. In fact, his facelessness was soon a selling point, the white label a must-have badge of elegance for those who could afford to be in the know.

Wooden floors and white walls were *de rigueur* in the trendy homes of the 1990s. But the ubiquity of the style did not stop publishers from cashing in with a series of popular books (left) detailing the mysterious ingredients of the perfect post-industrial interior. *Lofts*, by Marcus Field and Mark Irving (Laurence King, 1999), and *Space*, by Fay Sweet (Conran Octopus, 1999) encapsulate the anti-ornamental *zeitgeist*.

It was the entry of global retailers that gave simplicity the momentum it needed. In 1995 Ikea supported its drive to persuade us, as British advertisements put it, to 'chuck out the chintz' by launching PS, a range of furniture created by assorted Swedish New Functionalist designers. Since then, other global retailing giants have entered the market with basic goods that exploit our taste for simple forms, their products emphasising LOW-KEY, practical FUNCTIONALITY crossed with a modicum of wit.

It isn't just simple furniture and fashion that have been such a success. Japanese retailer Muji has made a virtue

≫→

"Good form, good function, and all at affordable prices. Design can be part of everyday life, in every home. At Ikea, we call it Democratic Design, and our new PS Collection is all about it."
Ikea catalogue, Spring 2000

In 1995, an Ikea ad campaign (above) urged
British shoppers to "Chuck out your
chintz" and discover the joys of self-
assembly furniture instead.
 The Japanese retailer Muji (opposite)
turns the conventional rules of branding
upside down. The most distinctive
thing about Muji is the self-conscious
anonymity of the No Brand label it
applies to everything it sells.

In 1998, 180 million people visited over 150 Ikea stores in 28 countries including China.

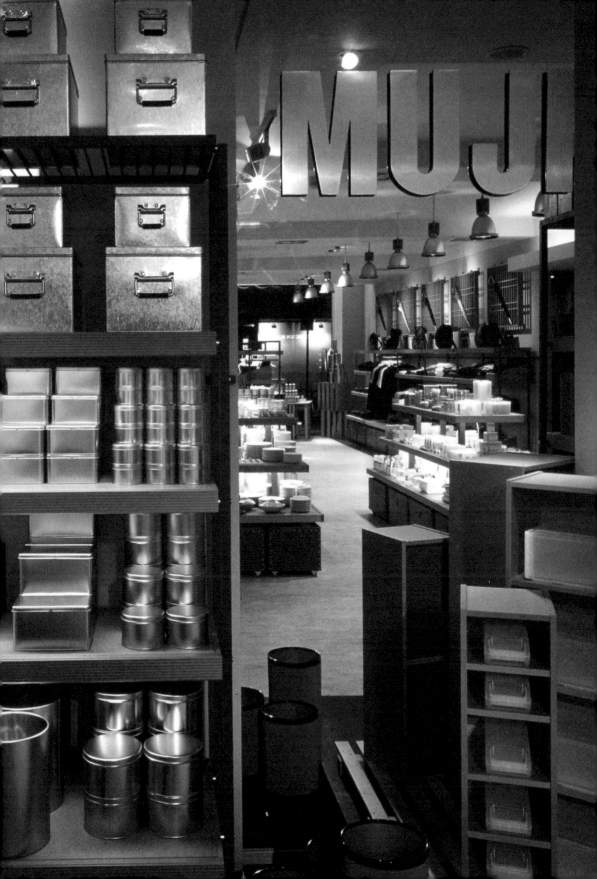

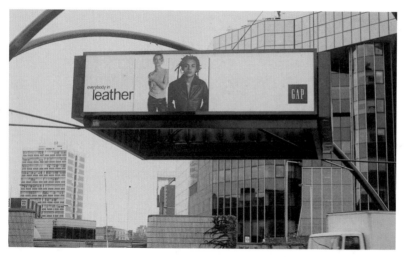

THE GAP INC.

Gap is known for products that are easy to live with and easy to buy. But this casual, 'easy' ethos isn't as straightforward and colourless as it might appear.

Founded in San Francisco in 1969, Gap is based on the simple premise that everyone needs basics and weekend wear. But functionality needn't mean sacrificing style: Sharon Stone famously wore a plain black Gap turtleneck with her designer outfit at the 1997 Oscars. With over 2,600 stores across North America, Europe and Japan as well as an online shopping service for US customers,

Gap Inc already has a large proportion of the world covered, and no potential target group remains unexploited.

Gap's success is built upon a range of no-nonsense generic staples; jeans, vests, T-shirts. Classless and ageless in its appeal, the well-priced, but predictable stock seems to have struck a chord with the public. It is the antithesis of fashion shopping conventions. Gap is home to the weary fashion shopper, a convenient outpost of ordinariness and dependability.

BabyGap and GapKids cater for the younger end of

the market with miniaturised versions of the company's trademark denim and practical tumbledrier-proof T-shirts. And 'fun, fashion, family and value' is the guiding principle behind Gap Inc's economy sub-brand Old Navy, which is set apart from the rest of the group by the use of cartoon graphics and 'Item of the Week' promotions. Shoppers aspiring to a more sophisticated look can graduate to the more upmarket Banana Republic, for understated 'classics'.

The anonymity of the clothing contrasts with the power of the branding. TV and

billboard advertising slogans 'Everybody in cords' or 'Everybody in leather' envisage a Gap-styled utopia – the whole world wearing the same piece of clothing. One size fits all.

Although Gap's approach is not aspirational these campaigns have proved to be an effective and memorable signature. Despite its 'non-aggressive' stance, Gap now dominates the leisure wear market. At the start of the 1990s it replaced Levi's as the brand most closely monitored by stock market analysts in the United States as an accurate indicator of the financial health of the nation.

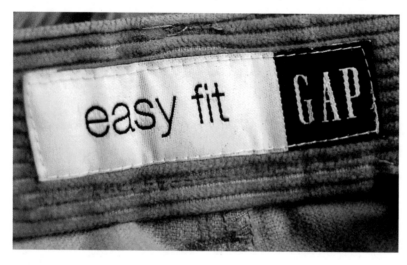

"Where Gap goes so does America. It took over from Levi's as the economic litmus some time ago."

Wendy Liebman, President of WSL Strategic Retail,

of anonymity, expanding swiftly in Britain by offering a 'No-Brand' collection of stationery and household items. This philosophy was a world away from the 'No Frills' approach still employed by some discount supermarkets to signify rock-bottom prices. Muji offered tasteful recycled paper notepads in slick Japanese packaging; plain brushed steel food containers; and even simply-formed sofa-beds with just enough styling to qualify as designer furniture. In the fashion sector meanwhile, Gap emerged as one of the world's most powerful retailers by applying an **anonymous classic** philosophy to its products.

Unlike the stripped back packaging of more upmarket products, the simplicity of Kwiksave's No Frills packaging (right) has no overtones of designer chic. The stark sameness of everything from pies to paint was intended to convey that the budget supermarket had cut expenditure on extras to the bone, passing on savings to the customer.

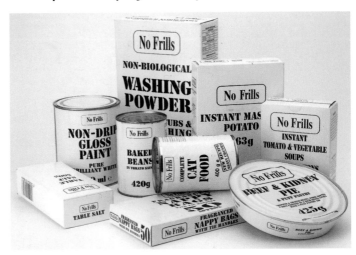

how to measure a women - will you remember me.mp3 - stovetop & espresso - Pretty Fly for a Rabbi tab - Boston's Men's Center

'Simplicity should become a permanent fashion' Edward de Bono, 1998

Simplicity is finding new supporters far beyond design. Edward de Bono, veteran 'thinker about thinking' has published *Simplicity; a book* (a little ironically, his 59th) devoted to 'cutting through the needless complexity of modern life'. In it he proposes, among other things, 'ten rules of simplicity', a worldwide simplicity campaign and the establishment of National Simplicity Institutes all over the world.

All around us, simplicity has begun to mean big business and the bandwagon is continuing to gather momentum. Against this sort of cultural backdrop, some designers are continuing to develop the language of New Functionalism. Throughout the 1990s, designers continued to develop furniture less exclusive and sometimes less pricey than designer chairs of old. And perhaps surprisingly, even now that the economy has picked up, British shoppers seem more receptive to these ideas than ever. We like surrounding ourselves with all these so-called 'design-because-you-need-it' basics because they are cool and

Michael Anastassiades specialises in objects whose function is a good deal more sophisticated than their simple looks suggest. His wooden beakers (below) contain a recording and playback device for the exchange of messages within the domestic environment, while the alarm clock table (left) vibrates instead of producing an ordinary alarm sound: it only works as an alarm if something which rattles has been placed on the table top.

Groups - download+crt - – vampiro - "Fantasy Basketball" - guinea pigs - skateboard - menegaki - "insane clown posse" +realaudio

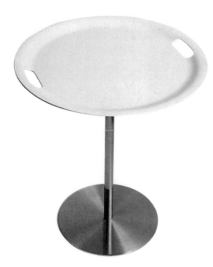

Jasper Morrison continued to bring elegant functionality to furniture throughout the 1990s. The 'Op-La' tray table from 1998 for Alessi (left) is a witty reminder of the lost tradition of butler service: the table top lifts easily from its metal base to become a tray, allowing for the easy removal of empty glasses.

inexpensive and, after all the glitz and glitter that has gone before, they somehow feel more straightforward, more honest, greener, more genuine, more authentic: an antidote to the increasing complexity of the world we live in and the decisions we have to make.

But simplicity is often not what it appears to be. Back in the early days of modernism – when the wonders of technology and mass production seemed to hold out the prospect of improvement for everyone – form was supposed to follow function because to many at the time it appeared to be the cheapest way of mass producing good design for the

≫→

- ALTERNATIVE ASSESMENT FOR EDUCATIONAL OUTCOMES - X-Com - caller id rejection - Window Coverings - "womens

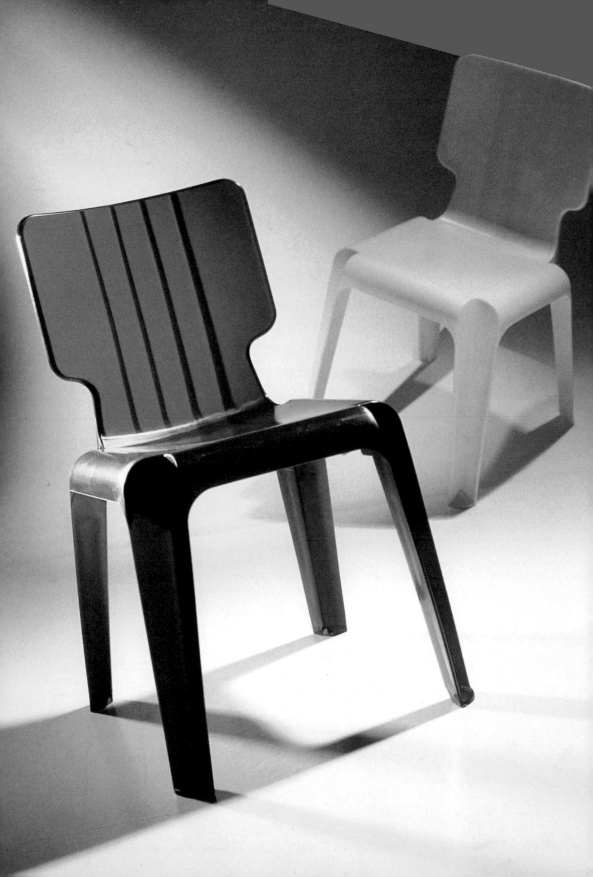

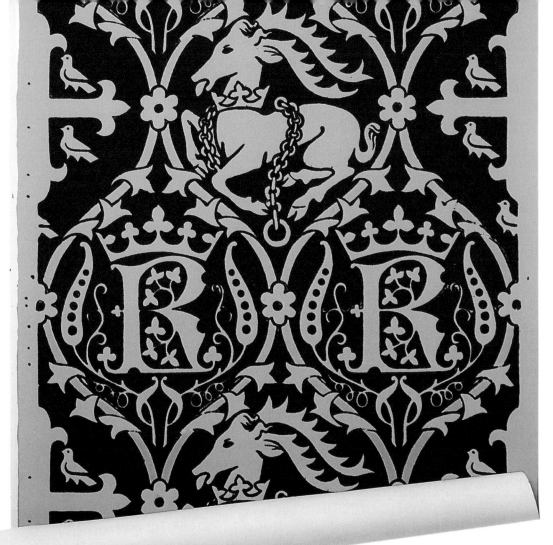

The 'Wait' chair (opposite), designed by Matthew Hilton as Authentics' first item of furniture, was conceived as 'a chair for the people'. Intended for indoor and outdoor use, its polypropylene form resembles that of the cheap garden chairs available from any DIY outlet. Managing Director Hansjerg Maier-Aichen claims that Authentics "strive to pare down objects to the essentials, and practises the art of making more with less".

Lord Irvine's (The Lord Chancellor, Britain's legal supremo) 'authentic' interior decoration might have cost him his job in 1998. Irvine spent £650,000 of public money refurbishing his Westminster home including £59,000 on supplies of this Pugin-designed wallpaper (above) hand-printed by Cole & Son of London. Criticised for extravagance, Irvine described the refurbishment as a 'noble cause', predicting that future generations would appreciate the refit.

In the supermarket cola wars, most brands were happy to indulge in basic copycat tactics to keep up with the brand leader (below). As well as mimicking the colour and the logo-style of Coca Cola, many of the other brands also played up the use of words such as 'original' and 'classic' to reassure customers of the apparent authenticity of the fizzy stuff within. Only Pepsi, which went blue and Muji (opposite) dared to be different.

maximum number of people. But this utopian ideal seems naïve and outdated today: the wonders of modern manufacturing technology, tooling and production mean that a product that looks complex and sculptural can be produced for the same price as one that appears functional and austere.

So it pays to be aware what buttons manufacturers are hoping to press when they opt for simplicity. The German housewares company Authentics has practically built a whole lifestyle from one material – its admirable range of translucent plastic products includes everything from waste-paper bins to chairs – but all are designed to be extremely

Evangelion AnimeT Shirts - baker act florida - nvidia rivatnt drivers for win98 - mia hamm - cw56rw - foreskin - wanderers - Populous

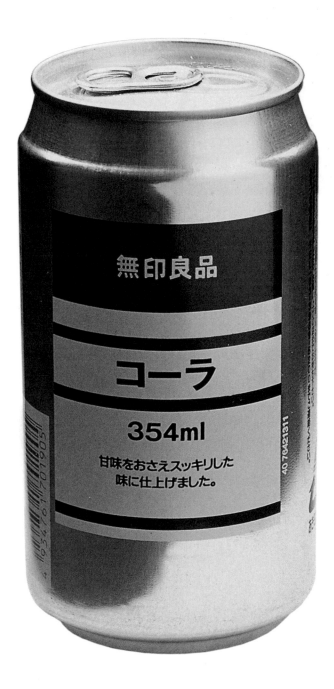

Because of their rarity value and their inflated price, Japapnese jeans brand Evisu became a cult. This started a spate of counterfeiting which produced this pair of customised Levis.

simple and inexpensive. The new Wait chair, for example, costs no more than a typical DIY store garden chair. Authentics' simple plastic goods are essentially no different from any others, but both the company's choice of name and its design-led approach seem to be calculated to maximise the brand's impression of originality and integrity. In the modern world, things are sometimes made to look simple because their shrewd manufacturers want us to read the right messages into them.

Marketers of 'minimalism' have perfected the trick of getting maximum value from the minimum of details. It is

"Consumers enjoy using our products. We take pride in mass-producing articles which stand out from the anonymous jumble by their restrained elegance."

Hansjerg Maier-Aichen, Managing Director, Authentics, 1996

"native american achievmaents - ass - holiday inn - black labs pictures - old erotic - universidad de chile - cordless telephone

clear from looking at room prices at London's least furnished hotel, the HEMPEL, that in this instance simplicity has little to do with either usefulness or value. On the contrary, guests are paying a premium for that extra bit of purity. For a certain group of rich and fashionable metropolitan types, choosing products replete with simple, expensive elegance signifies taste in a way that old fashioned **decoration** no longer can.

However difficult it may be to do well, in its commercial forms a minimal style is more often than not a signifier of exclusivity. To step into John Pawson's beautifully stripped back interior for Calvin Klein's New York shop is to discover

ORGANIC BASMATI RICE

As experienced consumers of simplicity, we understand that the minimal backdrop created by architect John Pawson for Calvin Klein's New York store (opposite and below) is hardly meant to imply that the underpants on offer are budget Y-fronts. Like simple packaging, minimal architecture is now often used to create an aura of exclusivity.

at once that these are products worth paying for and available only to a privileged cognoscenti.

In today's image-cluttered world simplicity is highly valued. We like the idea that we are clearing the clutter out of our lives. But our yen for simplicity may sometimes make our analysis of it too simplistic. Today it is often a status symbol, a contemporary brushed aluminium dashboard the equivalent of 1970s crafted walnut, modern raw linen the counterpart of flashy 1980s power dressing. 'Basic' is as much a fashion as a value. If we take style for substance we run the risk of ending up wearing the emperor's new clothes.

"What underwear do you wear? – Calvin Klein or nothing at all."

Calvin Klein T-shirt slogan

2. More

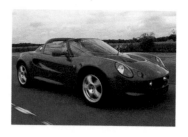

The proliferation of stuff

Observing the fantastic possibilities open to manufacturers today is sometimes almost enough to give one the surreal sensation of being a time traveller from the past observing a sci-fi vision of the future. The car industry feels more and more like that. A car can now be built from one lightweight piece of aluminium like the Audi A8, or held together by glue inside a racy shell like the Lotus Elise. And ground-breaking vehicles such as the Smart car have heralded the arrival of a new breed of vehicle that is as user friendly and as accommodating to personal taste as the mobile telephone. ⇒→

The evolution of materials has allowed engineers to revisit existing technologies in the 1990s. Instead of being welded together, the extruded aluminium beams of the Lotus Elise chassis (left) are glued with new polymer adhesives like an aeroplane. The chassis is ultra-light and cheap to make, and the body shell (above) does not contribute anything to the car's structural rigidity.

The Smart car's retailing strategy (opposite) was as daring and innovative as the vehicle itself. Despite this, the car has not caught the imagination of the automotive public.

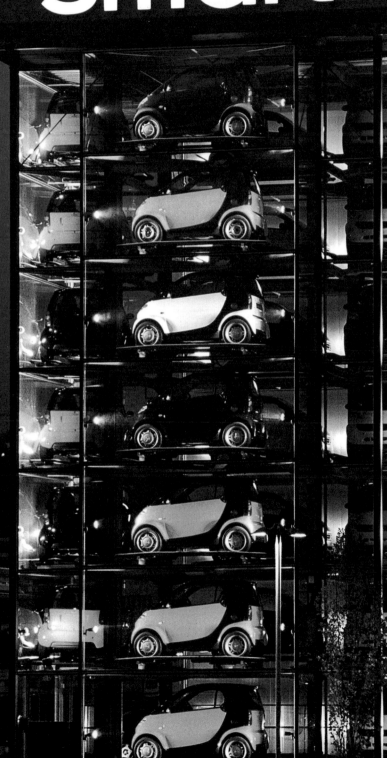
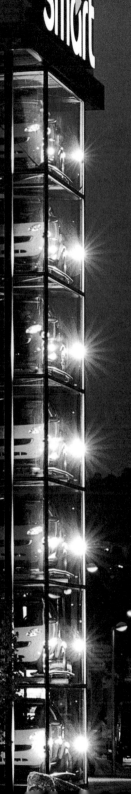

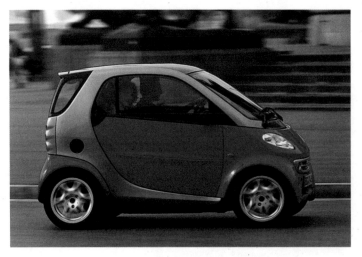

The 1990s has seen a host of launches of highly 'designed' cars which have been made possible by new construction technology. The Ford Ka (opposite), itself a standard-bearer for design-led cars, is constructed on a floorpan which may soon also provide the substructure for a model by Australian design superstar Marc Newson. Meanwhile, the Smart car (left) is an attempt to launch a two-seater city vehicle with body panels which can be changed according to taste.

The starting point for Mike Leadbetter's 'demand-responsive' shopping taxi (below) is the principle that a supermarket should take responsibility for the local traffic it generates. The electrically-powered vehicle can carry eight shoppers with shopping bags stored under the seats, allowing a fleet of 20 vehicles to cover the catchment area of an average supermarket. The concept has yet to be taken up by a supermarket chain.

Motor vehicles existing in the world would form a six lane traffic jam to the moon

Society of Motor Vehicle Manufacturers

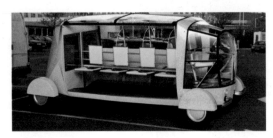

The average speed of cars moving through London has dropped from 12.7 mph in 1968 to just 10 mph today yet the Department of Transport predicts that road traffic will have grown by a staggering 35-70% by the year 2020. But the level of consumption of new cars is already extremely high. This is partly the result of a sea change in the reasons for buying them. Twenty years ago, many people still chose their car on the basis of reliability. Now, we trade-in more often, and cars are much less likely to break down: reliability is taken for granted by car buyers to such an extent that it is barely an issue

for manufacturers at the luxury end of the market (although companies with a reputation for unreliability have a major struggle on their hands).

Because technological sophistication is now a given, the design of cars has now taken its place as the key differentiator between models. 'Vorsprung durch Technik', the strapline which defined Audi's image in the 1980s, has quietly been dropped, and replaced by a commitment to design epitomised by the launch of its sports coupé, the TT, as well as the all-aluminium A8. This is not just a result of

technical standardisation, but also a response to consumers' desire for objects that transcend function and become extensions of their self-image.

Ford's chief executive, Jac Nasser, has cleared out the technically-proficient but boring models such as the old-style Mondeo and the clunky Scorpio, and launched a series of models with a new design style. This so-called, 'Edge Design' is a design-led ethos. Ford's new models do not claim to offer a technical or functional advantage over previous models. It has spawned the Ka, the Puma, the Focus and the Cougar to

date, and according to Nasser, has helped to bring the Ford brand image out of the suburbs and into the city.

Today people expect cars to reflect the way they want to feel. And in line with other areas of industrial design, car designs are being updated increasingly regularly. Manufacturers are happy to feed our thirst for new models, for new selves, and the latest production techniques allow this appetite to be satisfied ever more efficiently.

The globalisation of the car industry and the consequent release of huge investment funds for product

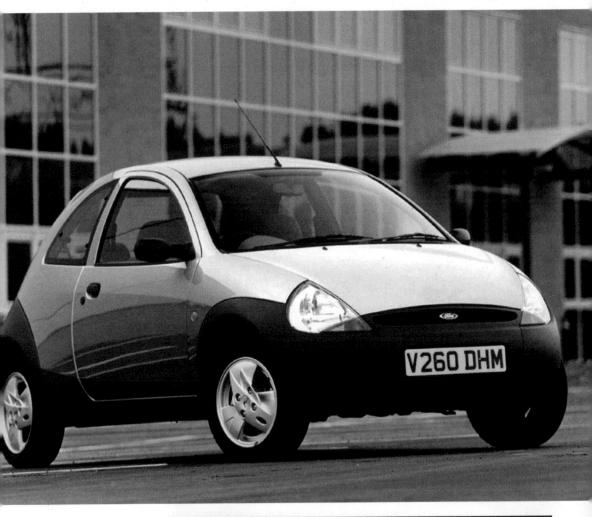

development have resulted in a growing trend towards multi-purpose car floorpans; standardised templates onto which a variety of different, increasingly expressive bodies can be 'dropped'. Removing the prohibitive costs of constructing a new engine or chassis for each model means that, theoretically at least, new car models could be turned out at practically the same rate as new trainers. The accelerating pace of development might help explain why the Department of Transport's traffic growth estimates for the future are so high.

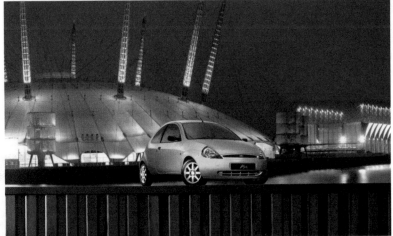

port access surgery - rhino crack - cheesecake factory - printer customer service ratings - linda lovelace - graphic porn - big & truck -

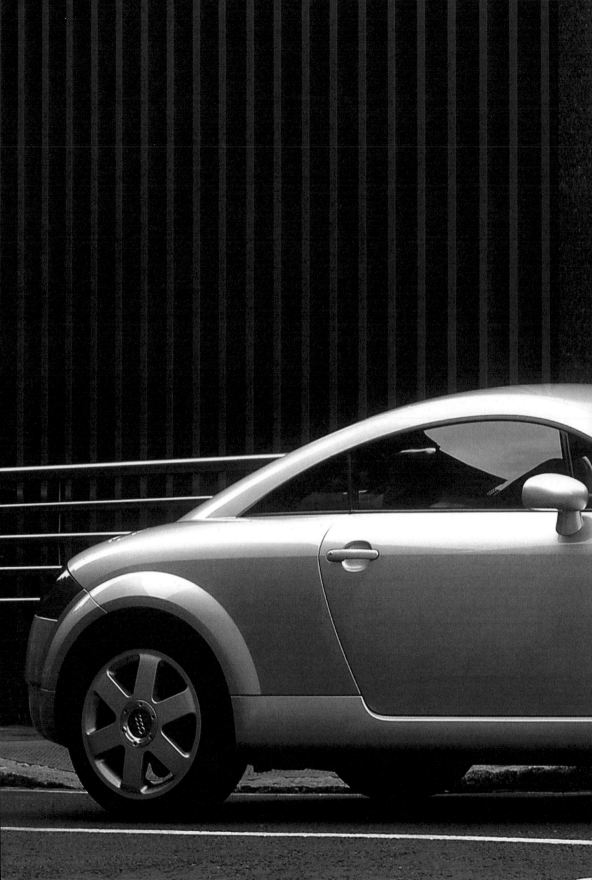

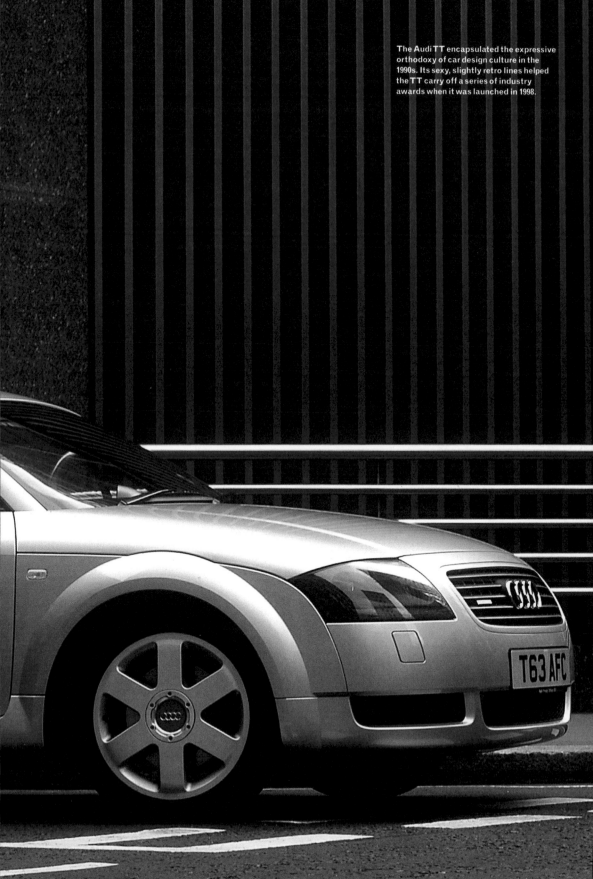

The Audi TT encapsulated the expressive orthodoxy of car design culture in the 1990s. Its sexy, slightly retro lines helped the TT carry off a series of industry awards when it was launched in 1998.

It is hard not to be excited by the enterprising spirit of the times. We are after all a generation that was brought up to view **choice** as a metaphor for progress. Today, **choice** has simply never been wider. Even British manufacturing – usually viewed as an eccentric anachronism – got the bug in the 1990s. From PCs to tea bags, consumer products are being rethought from scratch, and at the centre of it all is a new unfamiliar breed of entrepreneur. In the wake of James Dyson's world-conquering 'bagless' vacuum cleaner, designers are popping up to propose new and improved versions of products that have remained almost

➤➤

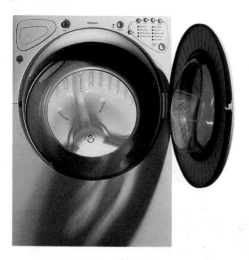

Stephen Kuester, the designer entrepreneur behind the Apollo pushchair (above) aims to do for the baby buggy what James Dyson has done for the vacuum cleaner. Like many modern buggies, the Apollo easily converts into pram mode. It features an enclosed bubble of fresh air which protects a baby's vulnerable lungs from pollution.

Conceived by naval architect-turned-entrepreneur Martin Myerscough with the help of product designers TKO, the Titan (left) looks as ordinary as any other washing machine until you open the door. The cavernous interior contains a removable plastic drum which inclines at an angle to allow easy access and to allow the machine to be opened safely at any time during its cycle. The drum can double up as an easily loaded washing basket.

road rash 2000 - pedro infante - freebsd modem - pamala anderson - Death Gifs - "Rumor Mill News Agency" - terry blum - komo

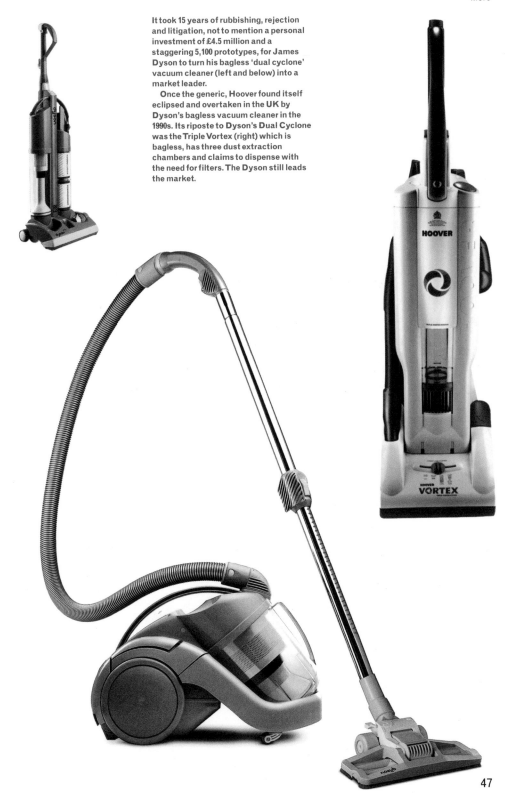

It took 15 years of rubbishing, rejection and litigation, not to mention a personal investment of £4.5 million and a staggering 5,100 prototypes, for James Dyson to turn his bagless 'dual cyclone' vacuum cleaner (left and below) into a market leader.

Once the generic, Hoover found itself eclipsed and overtaken in the UK by Dyson's bagless vacuum cleaner in the 1990s. Its riposte to Dyson's Dual Cyclone was the Triple Vortex (right) which is bagless, has three dust extraction chambers and claims to dispense with the need for filters. The Dyson still leads the market.

47

news - younges - porn stars - science fair corrosion - formal vamps - FLORIDA - slot machine info - Jonny Lang - "buildong muscle

At what point does innovation become novelty for profit's sake? The 1990s saw new versions of teabags in round and pyramid forms and even a variation equipped with drawstrings that allow the liquid to be wrung out without recourse to a teaspoon. The tea still tasted much the same though.

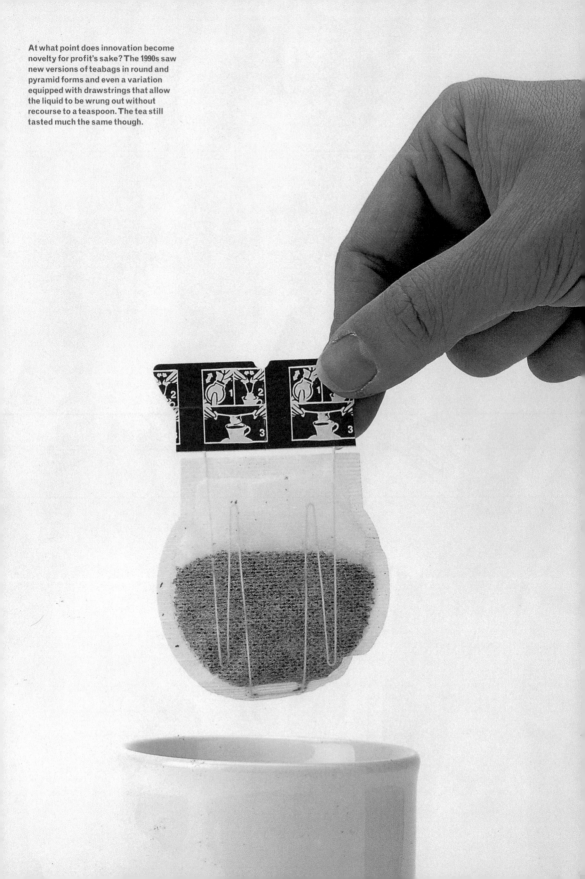

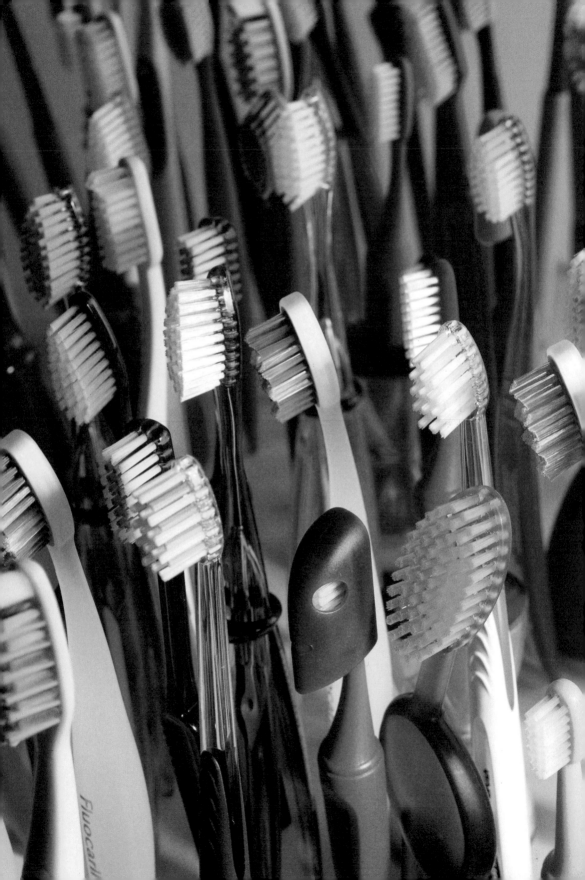

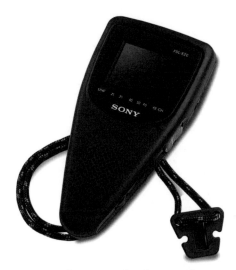

untouched for years: the pushchair, the washing machine, even the radiator.

It would have been hard to imagine this happening a decade ago. Designers have been telling us for half a century that they can make products more distinctive, useful and profitable, but at the beginning of the 1990s they seemed as far from winning the argument as ever. It sounded laughable on this side of the Atlantic when business magazines suggested that design would mean megabucks.

Britain has not, of course, become as enterprising and successful as California's Silicon Valley overnight, but the

A product's journey from innovation to obsolescence has become increasingly rapid. For instance, a design frenzy has hit toothbrushes in the 1990s (opposite). The Ozone's brush with a hole claims to flush away bacteria, while the different height bristles of the Oral B CrossAction are supposed to compensate for bad brushing. Many dental experts remain unconvinced that any one brush is more effective than another in preventing decay.

Sony's TV on a rope (above) is the latest in a series of portable televisions that electronics manufacturers have been tempting consumers with since the beginning of the 1990s. Its rarity suggests we are still not convinced of the need for yet more small-screen entertainment.

"Design is the corporate buzzword for the new decade."

Business Age, June 1990

"The US Government's classification of the G4 Power Macs as 'supercomputers' is no joke. A supercomputer is one which can deliver a performance of one gigaflop

[one gigaflop = one billion operations per second]

or more and any hardware which reaches this is automatically classed as 'munitions', and placed under export restrictions. This means Apple can't export G4 computers to countries classified as politically 'sensitive' to the US, such as Cuba and Libya."
MacUser, (UK edition), 17 September 1999

truly significant change is that alongside the people at the forefront of cutting edge thinking, the world's conservative establishment has bought into design culture. Increased efficiency, restructuring, downsizing and cost cutting were the values of the early 1990s, but increased efficiency alone is now viewed as yesterday's business solution. Today, the words DESIGN, INNOVATION and CREATIVITY trip off the tongues of managing directors, spin doctors and, perhaps most importantly of all in Britain, politicians who support that New Labour import, the Third Way.

Why is creativity a buzzword and why do designers

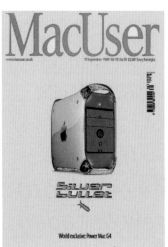

The cover of MacUser magazine, 17 September 1999 (left) celebrated the arrival of the new Apple Macintosh G4 processor. Rivalry with Intel's Pentium processing chip and the obsession with faster and faster processing speeds mean that computers rapidly become obsolete, sometimes within six months of their release. Apple's radical design revamp in shapely, coloured plastics heralded the end of the beige box aesthetic as a signifier for serious computing power. Meanwhile, an earthquake in Taiwan (where most of the world's RAM memory chips are produced) threatened a dramatic rise in the prices of computers.

52

suddenly seem to have both the confidence and credibility they previously often lacked? It seems that the opinion formers and analysts have taken a hard look at the commercial world and decided that there simply is no alternative. With competition continuing to intensify and companies finding ever cheaper places to manufacture their products, price is no longer a selling point for many goods.

Multinational makers of consumer products don't need to be told this, of course. They are already on the case. Take toys, for example. The global giants that dominate this business are now ready to spend tens of millions of dollars a year on

"It's never been a better time to be a business revolutionary... And it's never been a more dangerous time to be complacent."

Gary Hamel, Visiting Professor, Strategy and International Management, London Business School, 1998

design and fast-track new product development programmes that court and anticipate the tastes of their young consumers.

Nevertheless, if technology is the engine that has driven design to the top of the mountain, human nature is the fuel that drives the machine. In the post-industrial world we are more aware than ever of the options open to us, and choice changes people. We find it hard to believe in commodities any more. We want to feel that what we have is unique. Our products must be more seductive, more personal, more available, perhaps even a bit less expensive just to get onto our wish lists. In short, we're spoiled.

There is no better guide to the car trends of the future than the models that appear in the Royal College of Art Automotive Design graduation show. Simon Cox designed a Porsche Sports Utility Vehicle as a student in 1986. In 1996, his Vehi-Cross for Isuzu (left) bore more than a passing resemblance to the ten-year old concept, and had become part of the outward-bound 4x4 trend of the 1990s. Today Cox is director of design at General Motors.

The new technology of production and design has cut prototyping costs by more than half and slashed the time it takes to put a concept into production. Once prototypes took weeks to make. Now, a designer can create a three-dimensional drawing of a component or a product on computer in the studio and send the file to the manufacturer where a stereolithography machine will laser-cut a facsimile out of transparent resin which is perfect in every detail and dimension. The Polaroid camera by designers **PDD** (below) begins with a computer wire-frame drawing, is translated into a three-dimensional rendering, which then leads to the resin prototype.

Technology has brought us more speed as well as more choice. In fact, technological change is coming so fast that it feels exponential. In a decade, the mobile telephone has metamorphosed from a clumsy backpack to a palm-sized multi-purpose communication tool. Now it is changing again into something else. Today a designer can sketch an idea for a product on a computer and send the digital file direct to the client where a perfect full scale rapid prototype can be churned out for immediate inspection. And the lightning speed of production cycles means that the telephone's journey time from computer sketch to shop has been reduced ⋙→

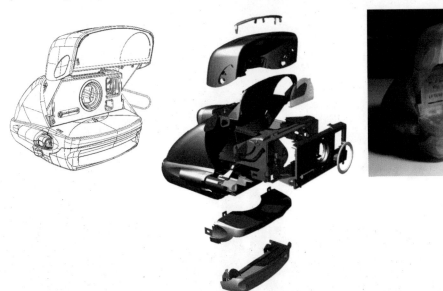

"Leslie Plant" - monster multimedia - boston terrier - wordweb - games - olyander - maple share libarry - low carbohydrates

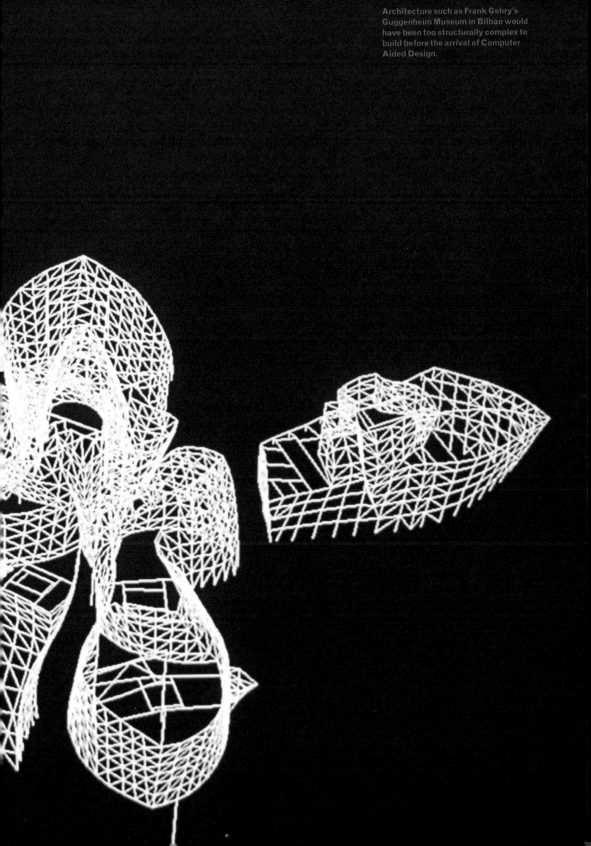

Architecture such as Frank Gehry's Guggenheim Museum in Bilbao would have been too structurally complex to build before the arrival of Computer Aided Design.

By the year 2005, Americans will be wasting almost 8000 centuries a year sitting in stopped traffic

Ecology of Commerce London 1993

from years to months. Want to survive? Then reinvent your products, your strategy, your industry every year. Whatever you want, it seems as if you can have the new version almost as soon as you've bought the previous model.

MORE PRODUCTION + MORE TECHNOLOGY + MORE SPEED = MORE POSSIBILITIES + MORE POSSESSIONS + MORE PROFITS. That's the way things work in this design-driven age of techno-capitalism. And for us it is an attractive formula. Most of us living in the wealthy parts of the world have never had it so good or so cheap or so fast and that's the way we like it. Literally and metaphorically, we are speed addicts, relishing

THE ARCHERS
In Britain, genetically modified food became an issue of such national importance that it featured on BBC Radio 4's long-running country soap, *The Archers*. Tom Archer was taken to court accused of destroying a field of his uncle's GM rape and eventually found not guilty.

"It's the first day of Tom's trial. At court, Corrine Holford, the prosecuting barrister, tells the jury that they are to hear a simple case. The defence will invite them to draw the conclusion that Tom had "lawful excuse" for his actions. The prosecution intend to prove that the plain facts of the case are that Tom acted out of bravado. He is a common criminal whose selfish act has caused widespread distress and upset. Michael Parrish of Bealtech gives evidence, explaining how GM crops are already being grown on around four million acres worldwide. In Britain, he says, careful trials are being undertaken. One of those trials was severely compromised following the destruction of one third of it by vandals. This could delay the commercial introduction of the crop by up to a year. Tom's parents, Pat and Tony in the gallery feel alternately hopeful and hopeless as the trial progresses. Tom's barrister Adrian Manderson cross-examines the Bealtech witness, bringing up the environmental risks that could result from the crop being grown. What environmental monitoring is going on? Very little, it seems. 'Fifteen love to us, Pat,' whispers Tony."
The Archers. *Episode written by Louise Page and Graham Harvey, first broadcast on Monday 25 October, 1999. This summary appeared on the* Archers *website.*

diets - pornno.com - Inner City Life Real Audio - zomba - sex - AOL Canada - airsponge - music colleges - Joshua Jackson -

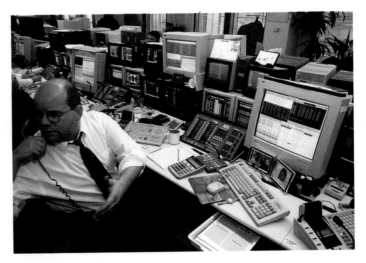

The constant drive for financial growth generated by the world's stock exchanges (right) is partly responsible for the growth in speed and consumption over the past ten years. Product designers have been among the beneficiaries, but many have also continued to ask questions about sustainability and the sensible use of resources.

every new speedy accessory, lapping up production's growing ability to get us everything we want as soon as we want it.

Except of course, we have a nasty suspicion that we are not facing up to things. We're not naïve enough to believe that design is simply the servant of material progress as we might have, even 20 years ago. Which of us really believes, for example, that the countless new ways of cleaning our teeth that dental technology has given us in this decade are really essential? Do we not have qualms about buying one of Dyson's vacuum cleaners in the knowledge that "electrical appliances bought by American consumers would

corless phone ratings - zwedish girls - North Grand V Theatre Ames Iowa - sim tower - halle berry - music charts -

With his ultra-streamlined versions of boots and bicycles (right), sculptor Martin Fletcher portrays an unsettling vision of a world now speeding so fast that it has left function and usefulness behind in its slipstream.

Our insatiable appetite for speed is epitomised by the explosion in new extreme adventure sports. The Coyote (below left), a rollerblade with huge wheels designed for rough ground, caters for those rollerbladers for whom skating in the park is mere childs' play.

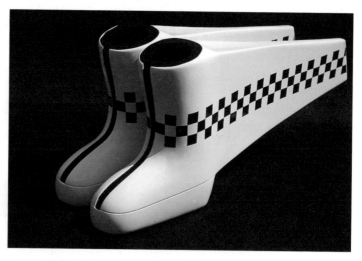

make 11 stacks as high as Mount Everest every day"?

Life's frantic pace gives us a buzz but we all know that there is a price to pay. Product gluttony has become an indulgence of the privileged few, not a necessity for the majority and our own insatiable appetite is threatening to eat us out of house and home. The apocalyptic facts about the price of ever-increasing consumption make it clear that we are accelerating towards the edge of a cliff. We may all know in our hearts that growth isn't everything. But more is our WEAKNESS and our ADDICTION. Are we up to making a choice between speed and sustainability?

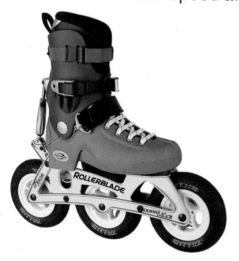

Ford has introduced a 'third age suit' (right) so that its designers can simulate the experience of being 70 years old. It was developed so that designers could experience first hand how old age affects our ability to use products. It simulates the normal effects of ageing, restricting joint movements and reducing tactile sensitivity with surgical-style gloves. Visual simulation spectacles reduce sharpness of vision, increase sensitivity to glare and provide a yellow tint – all characteristics of the ageing eye. The Ford Focus was the first car design to benefit from extensive use of the suit.

If the average age of a car buyer is now 45, why are all the advertisements pitched at an audience twenty years younger? The truth, one suspects, is that it is how old we prefer to feel.

We are facing what has become known as 'the demographic time bomb'. By 2050 half the adult population of the globe will be over the age of 50.

3. Control

The British Prime Minister surrendered control to the 'Virgin Vibro Chair' (below). As well as two loud speakers at head height, the chair's upholstery features vibrational resonators which transmit bass frequencies through the body.

When scientists finally succeeded in making a clone of a living organism, the result was Dolly the sheep (opposite), whose irresistible good looks made her an instant celebrity worldwide. But achieving Dolly was expensive and inefficient (her creation took 277 attempts), and her birth provoked a stormy debate about the ethics of reproductive cloning.

The illusion of power

We took it for granted that the last products of the twentieth century would provide more and more choice. But which of us can honestly say that we really anticipated the extraordinary sense of technological power that the arrival of the millennium would grant us? In retrospect, the new control we have acquired, both over life's trivia and its fundamentals in the past decade has been nothing less than astonishing.

'Mass customisation' allows us to personalise our jeans so that our legs look slimmer or to choose a cooker to suit a preference for Chinese food. We can play baseball with an ⤏

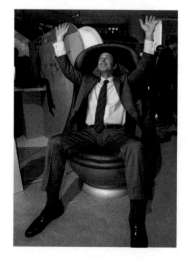

Levi Strauss and Co will make jeans to the exact measurement of each customer, in any of 4,224 combinations of hip, waist and leg measurements.

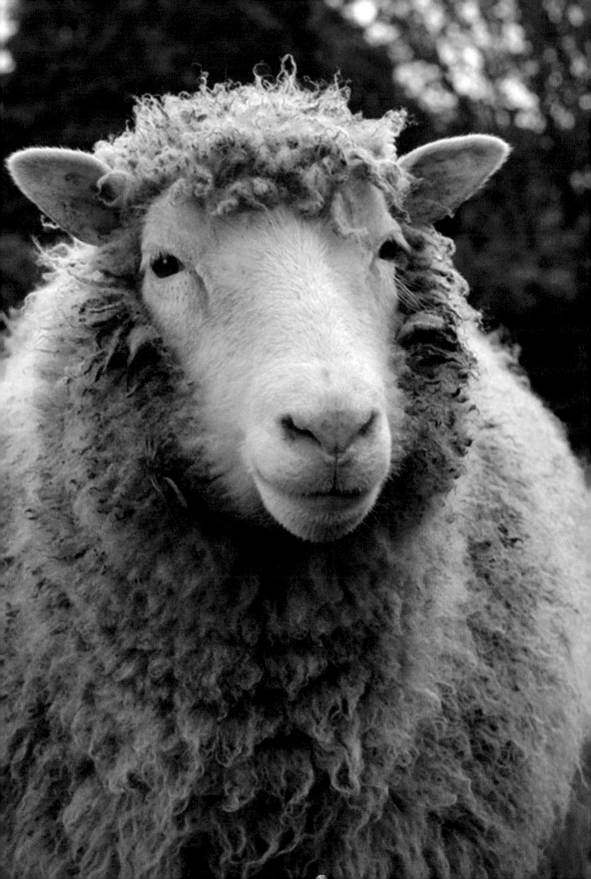

"Human beings can better relate to digital creatures than to PCs. The AIBO is a small but steady step towards creating a huge new industry"

Toshitada Doi, Senior Vice President, Sony Corporation, 1999

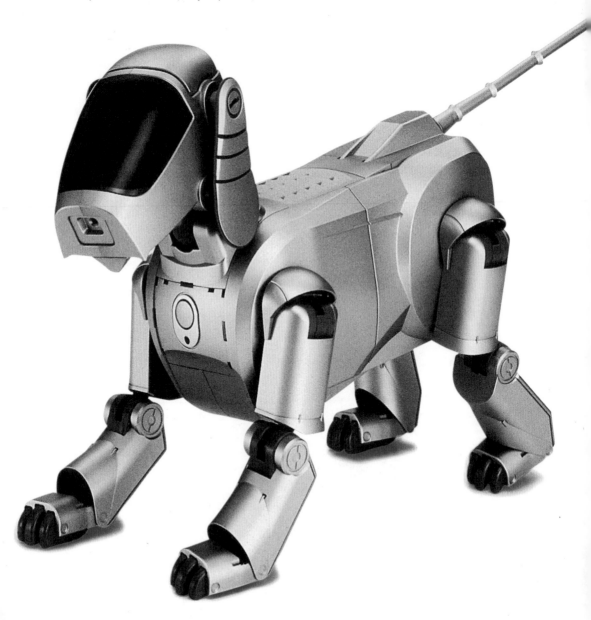

AIBO is Sony's robotic dog (opposite) which sees with infra red digital 'eyes' and can be trained to respond to familiar noises and to perform tricks. Launched in Europe with a price tag of £1600, the dog is not aimed at the same pre-teen market which bought the Tamagotchi and the Furby. Its original master Toshitada Doi, president of Sony's Digital Creatures Laboratory, predicts that as "the 1980s was the age of the PC and the 1990s was the age of the Internet... the 2000s will be the age of the entertainment robot."

The **Persona Natural Contraception Device** (right) indicates whether sex without a contraceptive runs the risk of pregnancy, showing a red light for 'yes' and claiming 95% accuracy. A Persona featured in artist Tracey Emin's Turner Prize bed installation at London's Tate Gallery in 1999.

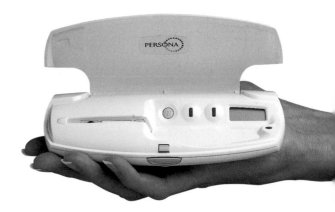

electronic bat that compensates for our deficient co-ordination by giving us Major League timing, OBSERVE the game of cricket from a stump's eye view, ORGANISE a football tournament with a team made up of Lego robots.

We can automatically MONITOR our daily fertility and choose when the best – or riskiest – time is to make love or we can use thermal cameras that help LOCATE and save fire or earthquake victims who would previously have been lost. Soon we may even be able to CLOTHE ourselves in garments which serve as the guardians of our personal well-being: one Royal College of Art graduate recently proposed the Techno-Bra –

The **Copperhead ACX Electric Baseball Bat** (above) features an electronic shock absorber which compensates for the extra vibration created by a mis-timed swing. The result is a baseball bat with an extra large 'sweet spot' which never jars the hitter.

65

"Technology is just a tool. We will learn to use it."

John Thackara, Director, Netherlands Design Institute, December 1997

The mouse was invented in 1969 and Logitech, long at the vanguard of 'point and click' technology (right), produced its 200 millionth product at the end of 1998. Today's mice range from work tools to specialist objects for gaming, reflecting the ubiquity of the **PC** in all aspects of our leisure and work activities. Perhaps inevitably, Mickey has muscled in on the mouse industry too (opposite, below). Even before the arrival of the iMac, computer users were already able to spice up their beige machines with a Disney version of the tool.

a personal-alarm-cum-garment that signals for help if its wearer is attacked or falls ill.

In a sense it still seems extraordinary how quickly we have become blasé about all these techno-wonders. Only a few years ago they would have astonished us. Now as experienced consumers of techno-capitalism, we demand control because the evidence is around us everywhere that we can have it that way.

Perhaps more than anything else, it is the rise of the PC that has instilled our growing sense of technologically-inspired confidence. It's amazing to think what impact a

EMAIL message
As recently as the mid-1980s the majority of offices in the post-industrial world did not possess a fax machine. Letters, telephone and the occasional telex message were the only means of communication other than face-to-face dialogue. The rise of the fax machine ensured that business could take place at higher speed, but it did not amount to a communications revolution: faxes continued to use the same rhetoric and conventions as traditional letters – the fax was simply a quick delivery method.

Ten years on, however, the rise in the use of email looks likely to have a much more significant impact, both on the personal and professional lives of those who have access to it. Email has achieved what the fax never has, by altering the very manner in which we communicate with one another. Today, it is possible to make direct and immediate contact with almost any business owner or client anywhere in the world, and the language of email communication usually dispenses with the formalities associated with 'snail mail'. We get straight down to business, and then

receive an instant reply. Perhaps as a result of this, email and the internet have given those with access to them a distinct competitive advantage. According to the US Department of Commerce, information technology has generated a quarter of business growth in the USA since the mid-1990s.

If this new way of doing business amounts to a structural change in the way we communicate, it is in turn having an impact on our behaviour. Because screen-based communications are now so easy, and because we are more likely to own a computer at home, it is

becoming more difficult to keep our personal and professional lives separate. It is possible to spend increasing amounts of time checking and replying to messages, and there exists the ever-more pressing apprehension that if we ignore our email for a few weeks we are likely to miss out on important business information. In this respect, our apparent freedom and accessibility, as well as enabling us, is in fact exerting its own form of control.

Although hailed by some net evangelists as the great democratic leveller, on an economic level, email and the

coast communtiy college - firstclass - winace.exe - Ricky Martin - university of virginia player - Batman ate my balls - consumer

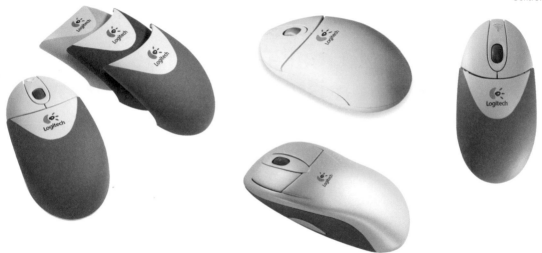

bunch of manufacturers in search of a market can have on the way we think. After their relentless pursuit of business in the 1980s that saw practically every US company install its own computer, hardware and software manufacturers spent the 1990s persuading us to take digital technology home with us.

We didn't need much persuasion. It has been a steep learning curve but many of us have made the transition to digital literacy. Ten years ago, we were still using manual typewriters. Now, many of us do our business by computer. There is probably no more powerful symbol of the new and intimate bond we have established with technology than the

internet actually appear to be helping preserve the status quo; at least for the time being. The countries – and people – already connected to the world wide web are those which are already wealthy and well-educated (in 1997, 66% of US households where one person had attended graduate school, owned a computer), and the US still accounts for almost 50% of all internet use. In the medium term, the internet looks likely to help the wealthy get richer, even if the fast-falling prices of computers do bring online communications and information within the reach of everyone else.

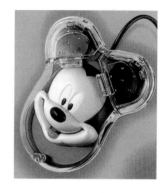

"Whichever country is able to make use of inventions and innovations fastest will come out ahead. I want that country to be Britain. I want Britain to lead the way in getting people online."

Marketing magazine, 1996

Gordon Brown, Chancellor of the Exchequer, 28 October 1999

computer mouse. Today, 'point and click' has become a phrase as familiar in our lives as 'mirror, signal, manoeuvre'. By the end of the 1990s, at least sixty per cent of homes in the USA had a home PC and Britain is going the same way. The supermarket, cinema, games arcade and social life can all now come to us. Website shopping is predicted to amount to £6 billion by 2003. In ten years' time, half of all retail sales may well be done via the internet.

And digital culture has made an even deeper impact on the generation born after 1970. For them, cyberspace is already home from home. Anyone under 30 at the turn of the century, in

Survey by Active Centre
Management Associates, 1999

Lara Croft (right), heroine of the Tomb Raider game, was the first fully-fledged video personality. The digital pin-up is now 'real' enough to be advertising Lucozade. She is also an official Millennium Product, which means that she is, in the opinion of Britain's Design Council, either 'innovative', 'of benefit to people', or 'kind to the environment'.

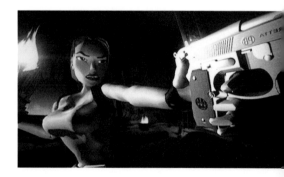

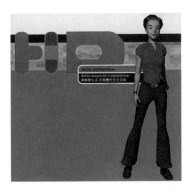

In 1998, the Department of Trade and Industry sponsored 'High Definition' (left), the British Council's exhibition of "British designs for a digital future". The show had a virtual hostess, Kate Young, created by Deepend Design.

fact, is quite likely to be a fully fledged MASTER OF THE DIGITAL UNIVERSE. It would have been impossible to imagine even five years ago, for example, that Lara Croft, pneumatic star of the Tomb Raider video game would be 'real' enough to be advertising soft drinks or would be worth an estimated £300 million in exports. We may have been willing to buy dreams from Mickey Mouse or even Ronald McDonald but Lara is the first truly three-dimensional fantasy character, the vanguard of an emerging line of virtual pop stars, bank tellers and even supermodels.

Video gaming has become a $6 billion industry which has ⫸→

Designer's own estimate

- gourd - " fugazi" - icma retirement - chat - "oil painting techniques" - Red Hot Chili Peppers I could have lied - mega satelitte tv

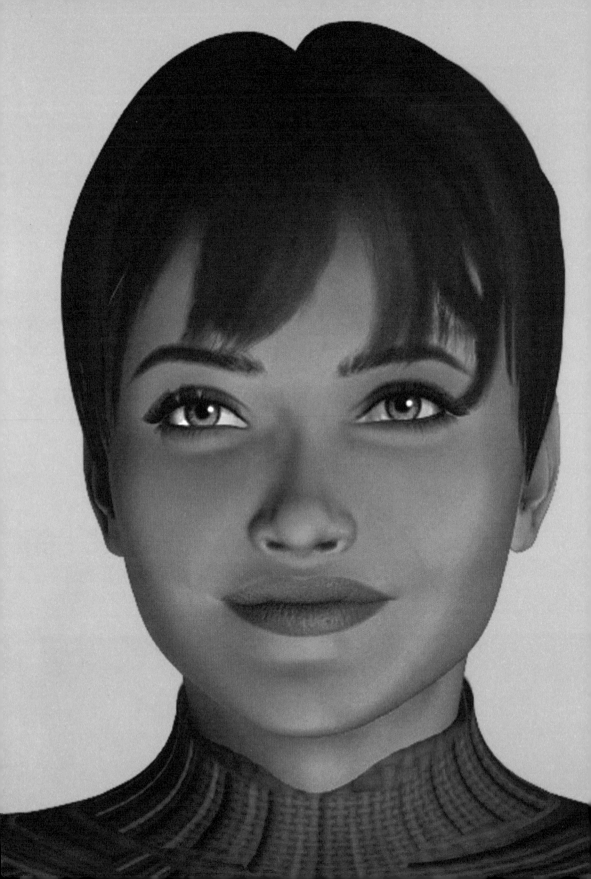

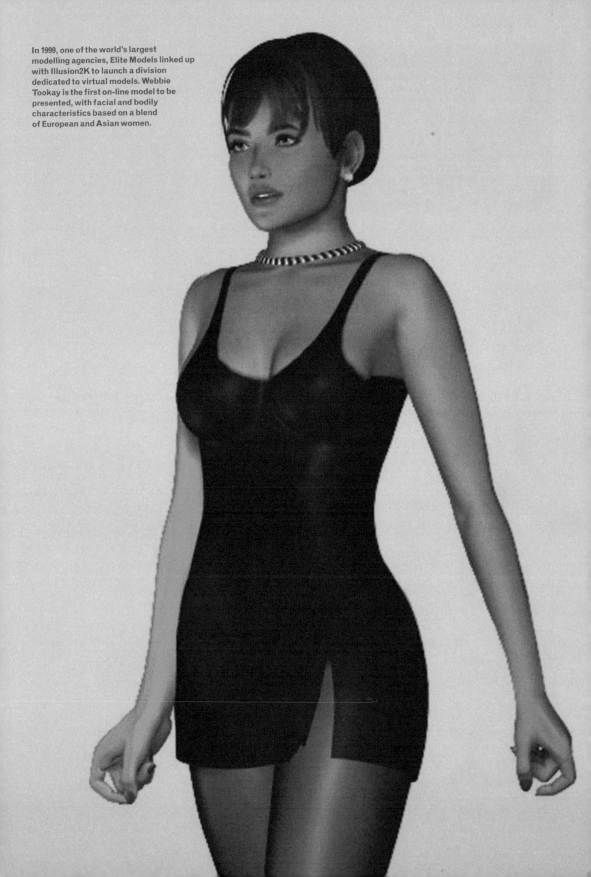

In 1999, one of the world's largest modelling agencies, Elite Models linked up with Illusion2K to launch a division dedicated to virtual models. Webbie Tookay is the first on-line model to be presented, with facial and bodily characteristics based on a blend of European and Asian women.

Hollywood movie producers running scared. Sony, market leader in video games ahead of rivals Nintendo and Sega, has already sold 50 million playstations worldwide. Today one fifth of British, a third of American and half of all Japanese homes have a games console. Just seven years after the launch of the magazine of the same name, the world – or at least its wealthy parts – is well and truly *Wired*.

Inevitably, gaming culture has become an important global force. How depressing then that so much of its appeal seems so one-dimensional. The title of one of gaming's leading British magazines, *Total Control* says it all. For all the virtuoso

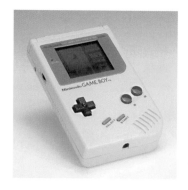

Sonic the Hedgehog (above), a classic computer game character of the 1990s, was relaunched by Sega in 1999 as part of its new Dreamcast system. With its built-in modem and internet access, Sega's Dreamcast console (left) seen here in a still from a 1999 advertising campaign, promised to add a new interactive dimension to the lucrative games industry and thereby steal a march on Sony's rival PlayStation system. In a market dependent on novelty and state-of-the-art technology, Nintendo introduced a range of accessories that allowed people to take photographs (and even print them out on a specially-made machine) using their hand-held GameBoy (right).

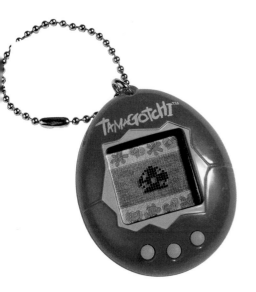

hyper-reality of their landscapes – filmic accuracy extends from the rustle of wind through the trees to the perfect ring of ripples on a pool – many of these games seem to follow the same simple-minded format. Search, fight, die and start over until you dominate. Mastery is the name of the game.

Total control. In a world in which real and virtual worlds are blurring at the edges, in which we can learn, earn, socialise communicate, exchange, buy, sell, bank without even leaving the house; in which so many of the products that surround us reinforce our sense of autonomy, would it be altogether surprising if we started to believe our own hype?

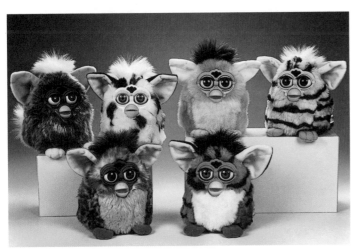

The apparently harmless Tamagotchi (above) turned into the 'original virtual reality pet' that parents loved to hate. The Tamagotchi craze of late 1997 cooled off quickly enough, but the technology was already evolving into new forms.

The Furby (left) took the idea of a virtual pet to new levels of sophistication in 1998. Each Furby responds to light, touch, sound and motion by moving its eyes, ears and mouth. It performs tricks, sings songs, plays games and says 800 phrases.

gardening - veronica reit - melissia Joan Hart - Nes roms - Best Western Hotels - painless mouse traps - Florida pornography - U S

POKÉMON

It might seem surprising that what toy manufacturers call Electronic Learning Aids – computers designed to look like toys – have rarely topped the British toy charts during the 1990s. Top sellers of the decade have been traditional dolls and their accessories and 'male action figures'. Barbie enjoyed a big revival in the middle of the decade, and Action Man has prospered since his makeover and relaunch in 1993.

But the 1990s may mark the final fling of such traditional toys as a new electronic wave is sweeping the market in the form of the Pokémon, which arrived in the UK in October 1999. Pokémon are electronic monsters which began life as a game for Nintendo, selling 12 million copies in Japan and helping to boost sales of the Game Boy by 250%. The game involves training 150 Pokémon characters to fight and then sending them into virtual battle – the more training they are given, the stronger each one becomes.

But gaming was just the start. Pokémon has already spawned a top rating TV show in the US, a record and a film, and is already estimated to be worth in excess of £3 billion world-wide. The game's merchandise potential is huge; the UK launch was accompanied by a range of spin-off products which included soft toys, sweets and toiletries. The particularly cunning thing about the Pokémon characters is that they seem to cover every play option you can think of. They have the cuddliness and interactivity of 'virtual pets', the excitement of video games, and the variety that flash-in-the-pan predecessors such as the Ninja Turtles and Power Rangers couldn't offer. It has proved an addictive combination. In America, some have even christened Pokémon 'kids' crack'.

Their creator Satoshi Tajeri is determined to ensure that the 'pocket monsters' retain their grip on kids well into the next century. Tajeri, who works for the Japanese company Gamesfreak, is already working on a new batch of 100 more characters.

of business - devil's fingers plant - nude AND boys AND fe - real time keystrock log - foreign bank holding association - "marky

The Aboistop (left) is a technology-driven tool that allows pet owners to modify the behaviour of their animals. Worn around a dog's neck, the Aboistop responds to persistent barking by releasing a burst of citronella spray to calm the animal down. Similar devices on the market include a remote control device which allows an owner to administer a small electric shock if the dog misbehaves.

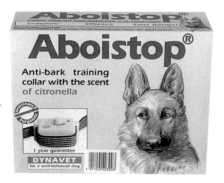

We imagine control as a benevolent force when it is in our own hands. Criminal tagging devices or city centre surveillance cameras both seem like a good idea and, if our car breaks down, it is reassuring to know that the RAC can accurately pinpoint our position by tracking a mobile phone. But what do we make of the appearance of spy shops on our high streets or the creation of call monitoring services in the US which can be programmed to record and analyse any phone calls in which words like 'Saddam Hussein' or 'communism' are mentioned?

The technology that empowers us also grants others

"Let's imagine you have a child who may well inherit the genetic disease cystic fibrosis, which causes congestion of the lungs and so on. It would be possible to obtain an embryo, confirm that it had the DNA effects, then to grow out cells from that embryo in order to be able to correct the error, then to do a nuclear transfer to produce a new embryo so that you correct that disease not only in the child but in all subsequent generations... Once the technology is there to correct diseases it could also be used to alter personality. We really know so little about ourselves and what makes us what we are, that I think it would be folly to think of doing this in the forseeable future."
Dr. Ian Wilmut, creator of Dolly the Sheep, in a lecture to the American Association for the Advancement of Science, 12 February 1998

mark" + pics - raptor firewll - mygeek - pitching - pezarro mobili - N64 wrestling roms - gameboy programming - employee satisfation

control over our lives. Some conspiracy theorists even subscribe to the idea that someone clever in the Pentagon came up with the concept of the Internet. What better way of spreading the word about international capitalism, they suggest, than by cutting out the middle man and going direct to everyone with a computer and a phone line. Once you have got people to buy in the main winners are likely to be the giant capitalist corporations. No need for **nuclear warheads** when you can dominate every country by getting them to plug in, turn on, and shop out.

The influence of these faceless forces in our lives can only ➤➤

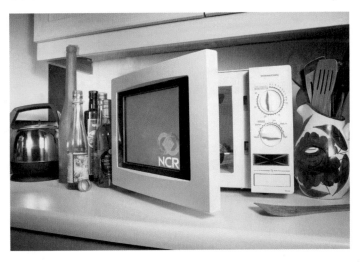

The Microwave Bank (right) is a prototype created by the Knowledge Lab, the 'think tank' department of NCR, inventor of 'hole-in-the-wall' banking. It is conceived as the modern home's multi-purpose communication centre and allows a family to bank, shop, check recipes and send messages from the comfort of the kitchen.

- MIME download - doublecut cock - harley davidson - Lord of the flies - horoscopes - lincoln-douglas debate - Robert Cogen - wild

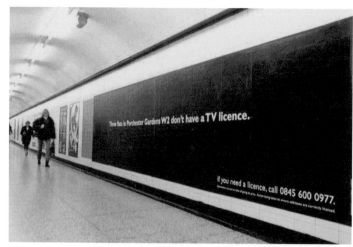

NOTICE
Concealed CCTV cameras operate on these premises

Electronic tagging is conceived as an alternative to prison for minor offences. A plastic tag (below), fitted to the offender's ankle or wrist, emits a signal received by a monitoring unit in his or her home. All events are reported automatically to a central computing system where they are checked against a client's curfew conditions.

Monitoring technology supposedly allows the television licence authorities to find out whether non-licence holders are watching television. The fear generated by such surveillance was exploited in a series of advertisements in London in 1998 (above right).

Disquiet about possible contraventions of human rights grew as quickly as the technology itself. Fashion designers Vexed Generation (opposite) designed a coat which could protect the identity of its wearer from CCTV cameras. Meanwhile Hussein Chalayan created a plastic dress (right) whose form could be altered by remote control.

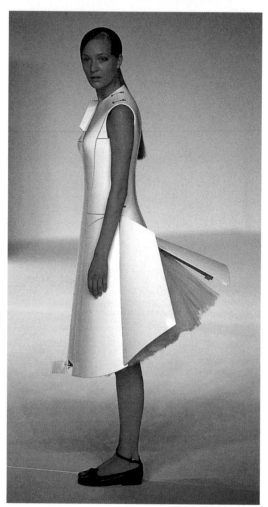

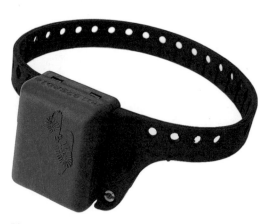

The 'Baby Think It Over' infant simulator (right and opposite) is like a giant Tamagotchi designed to educate children and teenagers about the uncomfortable realities of parenthood. It requires feeding, rocking, burping, nappy changing and comforting, often in the middle of the night or at other inconvenient times. The simulator, which has been very effective in the United States, can even be programmed to be particularly 'fussy', and displays whether it has been roughly handled or neglected by its young carer. Ethnicities include everything from light-skinned African-American babies to American Indians, while variations also run to a drug-dependent infant simulator which is smaller than average, has body tremors simulating withdrawal and emits the anguished cry of 'crack babies'.

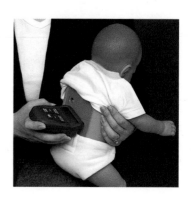

increase as e-commerce gathers momentum. Some IT experts are now predicting the dawn of the era of 'distributed computing'. In this scenario, homes will eventually have their own mainframe computer feeding pieces of hardware tailored according to each room's digital requirements – education and entertainment to the children's rooms, recipes for the kitchen and so on. NCR, creator of 'hole in the wall' banking has already responded to this with the 'microwave bank'. This ordinary looking kitchen appliance includes a flat screen monitor which allows you to check the weather, find and download recipes from the internet, pay bills,

"Hi Guys, I'm Becky, one of Barbie doll's school friends. As the school photographer, I get to take pictures at all the school events and stuff. I even won an award one year for a picture I took of our Girl's Basketball team. Well, gotta go now. Hope we can get together and play real soon. See ya!". *From presentation box in which Becky is purchased.*

steele - kouva - Eco - vasovagal nerve - visual analyst 7.2 - escrambler log - xg midi - online rpg games - sailing ship simulator - FTP

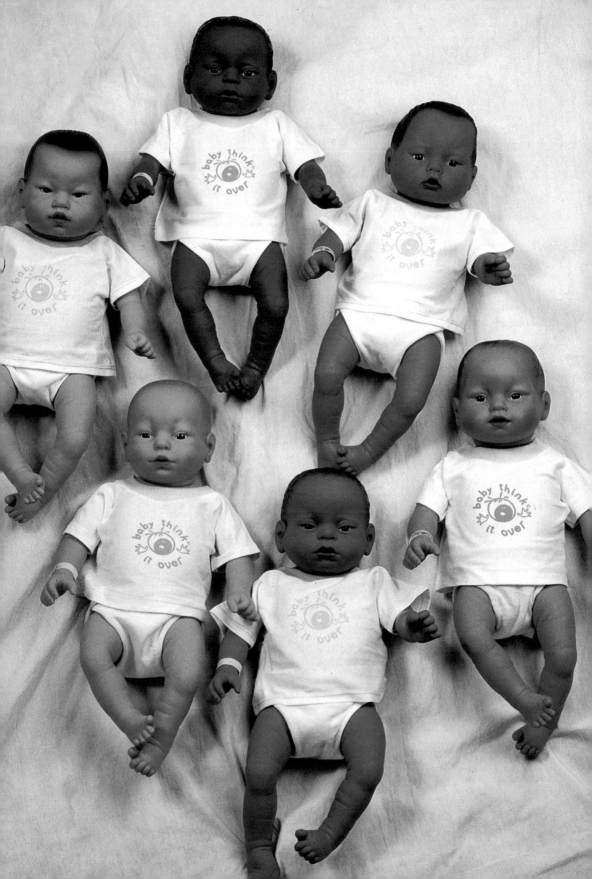

lady p.

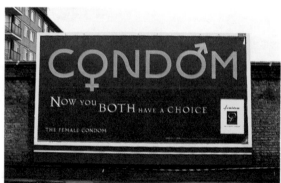

CONDOM
NOW YOU BOTH HAVE A CHOICE
THE FEMALE CONDOM

check shopping lists and read your email.

We may celebrate the advent of distributed computing as more control and convenience for ourselves. Observed from a more jaundiced viewpoint it looks a bit like welcoming Big Brother into the house and simultaneously giving him access to our wallet and credit cards. With the growing sophistication of e-commerce, retailers of all kinds are finding new ways of manipulating their customers, keeping them on their websites and acquiring new information about them so they can anticipate and respond to their needs.

As the internet spreads, control of our lives may be slipping

"Each home may eventually have its own mainframe box tucked away in the basement which feeds distinct applications in separate pieces of hardware for different needs."

Gillian Crampton Smith, Head of Computer Related Design, Royal College of Art, 1997

According to its Dutch manufacturer Sphinx, the Lady P. urinal (above left) is both a more hygienic and quicker way to pee for the 'modern, self-confident' woman. It remains to be seen whether this latest example of the 'feminisation' of a product previously exclusively associated with men will prove more successful than the female condom launched in Britain in 1992 (above right). Introduced at a time when AIDS-awareness meant that condoms were once again becoming the contraceptive of choice for many, the Femidom nonetheless failed.

This has been the era when designer drugs seemed to offer new possibilities for controlling everything from our mood to our potency. While Viagra (left) and Prozac were hailed by some as wonder drugs, others had their doubts, arguing for example that Prozac caused agitation, aggression and worse. Meanwhile, among illegal mood-changers, Ecstasy (right) became the big narcotic feel-good craze before fears about its short-term dehydrating effects and long term impact on our neurones began to make people think again.

out of our hands and into those of the international **corporations** and **tycoons.**

Even so, the temptation is to assume that technology provides a solution to all of our problems. We have designer drugs to control our mood and our potency; machines that make skin, simple techniques that allow us to change the shape of our bodies. We have technology that allows us to shape life into the forms that best suit us and even to replicate ourselves. Some predict that it may soon be possible that many of us will have been surgically implanted with a StarTrek style microchip that monitors our blood

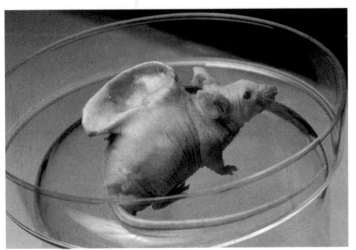

When this photograph (left) first appeared in newspapers around the world in the mid-1990s, it seemed to confirm all our neuroses about cloning and genetic engineering. In fact, this human ear grown on the back of a specially-bred mouse by Dr Charles Vacanti at the University of Massachusetts Medical Center represents a scientific breakthrough that could have a major impact on many lives, from growing replacement organs for transplant to revolutionising reconstructive plastic surgery (children born without ears were the inspiration for this particular experiment). According to Dr Vacanti, this is only the beginning: "In the future people will see our chemical-based medicine as clumsy and archaic. They'll find it difficult to imagine what healthcare was like without tissue engineering."

REDESIGNING THE BODY

Recent developments in new technologies look set to create a future full of opportunities to alter, augment or maybe even partially bypass our bodies. The signs are that this may be at a level of sophistication most of us can still barely imagine. Since the early 90s, designers and artists have produced work which responds to the increasing plasticity in the ways we already think about our physical selves.

In 1992, artist-designer Dan Friedman and curator Jeffrey Deitch produced an exhibition and an accompanying book, both called *Post Human* (above), which examined the way in which human consciousness might be changing. The book juxtaposes pictures of a 'Before & After' Ivana Trump or genetic engineering equipment with lines like "The matter-of-fact acceptance of one's 'natural' looks and one's 'natural' personality is being replaced by a growing sense that it is normal to reinvent oneself". The premise of this

introductory montage is that like any other material object, the body could undergo a radical transformation.

This idea was already being made in the flesh by the many people who were choosing to undergo cosmetic surgery. We are the first generation to have the option to rid ourselves of imperfect genetic legacies and create physical selves that correlate more exactly with the images in our heads. As the decade progressed, cosmetic surgery became more and more acceptable, as 'out and proud' advocates of nose-remodelling or liposuction began to articulate publicly the view that what they were doing was not subverting

but improving on nature. The theme of cosmetic enhancement has also been taken up by artists, who as a result of new technologies have been able to use their bodies as a canvases.

Perhaps the most challenging example of this is the work of French artist Orlan (overleaf) who, using her own face, plays provocatively with ideals of physical attractiveness and the acceptability of using the body to express our cosmetic fantasies. Having spent years carrying out a plan to remodel herself into a 'composite' beauty (using specially-briefed cosmetic surgeons to remake her mouth to match that of Botticelli's Venus, for example), Orlan then had nodule-like silicon 'horns' implanted into her forehead. Her most recent work illustrates further 'Self-Hybridisations', new faces achieved in the less painful context of the 'virtual surgery'.

Other artists are going beyond the cosmetic application of new technologies to consider their potential to change

the way the body actually functions. The Australian artist Stelarc pronounced that "the body is obsolete", and questioned whether as biological forms we are capable of dealing with the volume and speed of the information we are already bombarded with. Using robotic arms, electrodes and computers to supplement and control his own limbs, Stelarc explores the possibility of a more efficient, composite body.

But reality is proving to be as, if not more, radical than these conceptual enquiries. Having already produced bio-engineered skin and other replacement tissues, scientists have now begun to work on building organs from scratch. Although bespoke livers may be some way off in the future, other smaller-scale achievements are now being put to the test: human trials for a new blood vessel which is 20-times as strong as a normal blood vessel have already been scheduled as part of a research programme at Quebec's Laval University School of Medicine.

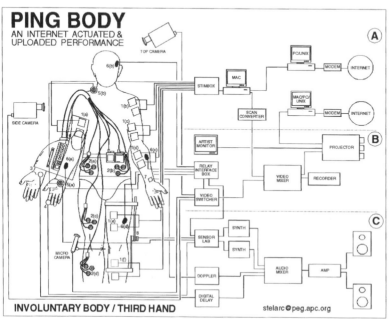

San Francisco Spine - atm refurbished - "Sexy Pics" - "soundde sal kids" - B & W - sonic hedgedog - warriors path inco - Black Bears

STELARC: OBSOLETE BODY

It is time to question whether a bipedal, breathing body with binocular vision and a 1400cc brain is an adequate biological form. It cannot cope with the quantity, complexity and quality of information it has accumulated: it is intimidated by the precision, speed and power of technology and it is biologically ill-equipped to cope with its new extraterrestrial environment.

The body is neither a very efficient nor very durable structure. It malfunctions often and fatigues quickly; its performance is determined by its age. It is susceptible to disease and is doomed to a certain and early death. Its survival parameters are very slim – it can survive only weeks without food, days without water and minutes without oxygen.

The body's **LACK OF MODULAR DESIGN** and its overactive immunological system make it difficult to replace malfunctioning organs. It might be the height of technological folly to consider the body obsolete in form and function, yet it might be the height of human realisations. For it is only when the body becomes aware of its present position that it can map its post-evolutionary strategies.

It is no longer a matter of perpetuating the human species by **REPRODUCTION**, but of enhancing male-female intercourse by human-machine interface. **THE BODY IS OBSOLETE.** We are at the end of philosophy and human physiology. Human thought recedes into the human past.

STELARC is an Australian-based performance artist whose work explores and extends the concept of the body and its relationship with technology through human|machine interfaces incorporating the Internet and Web, sound, music, video and computers.

As guest editor of style magazine *Dazed & Confused*, fashion designer Alexander McQueen was responsible for a ground-breaking fashion shoot by Nick Knight in 1998. All the models were physically disabled: the powerful cover image (opposite) showed athlete Aimee Mullins wearing the sprung-metal 'running legs' she uses in competition. Mullins summed up the spirit of the project: "I don't want people to think I'm beautiful in spite of my disability but because of it. It's my mission to challenge people's concept of what is and isn't beautiful." She went on to model in McQueen's Spring/Summer 1999 catwalk show, wearing hand-carved, high-heeled wooden 'boots' and was also one of the stars of an advertising campaign for mainstream clothing company MEXX.

At a time when the silicone-enhanced Pamela Anderson Lee was the world's favourite pin-up, cosmetic surgery became an increasingly acceptable option for women striving to attain a narrow and unrealistic definition of beauty. But worries about leaking implants and inexplicable illnesses forced the 2,000,000 women with silicone implants (above) to consider whether their health was a price worth paying, with famous former implantees from Loretta Lynn to Anderson Lee herself changing their minds. In the mid 1990s, manufacturers turned their attention from making implants ever more realistic to making them safer, switching from silicone to a saline solution.

Landmines have emerged as a modern, man-made plague. Some mines scattered around the world may have lain dormant for years, but they remain horribly effective and difficult to clear, killing 2,000 people every month – one person every 20 minutes. This selection of anti-tank and anti-personnel mines (opposite) was dug up after the recent cessation of hostilities in Bosnia. The mines are ignited by simple mechanical pressure. The trip wire-activated M-Rud anti-personnel mine (bottom right), contains 650 steel balls, each 5.5mm in diameter. On detonation, these ball bearings become lethal projectiles, covering a distance of up to 50 metres.

pressure, temperature and heartbeat.

Yet everywhere the evidence of our impotence surrounds us. The 1990s saw the development of new sorts of land mines as well as high profile campaigns to put an end to them. Africa is the continent most heavily afflicted today, with around 30 million mines spread throughout eighteen different countries, according to United Nations estimates. Meanwhile, our medical revolution still seems powerless to stop the diseases that afflict us. In the 1990s, BSE terrorised Europe. HIV swept on remorselessly, with AIDS devastating Africa and establishing itself all over the globe. Diseases like

Number of unexploded mines buried across the world: 100,000,000 United Nations

salmonella, chlamydia and tuberculosis grow ever more resistant to our attempts to control them with antibiotics and anti-viral drugs.

After a century of developments at breakneck speed, our technology-driven world combines both the choice we already take for granted with a reassuring, sometimes apparently divine sense of autonomy. But the danger of a world that works to our convenience is that its seductiveness makes us overestimate our own power. Once we saw control as our ultimate weapon. Close up, it looks much more like a double-edged sword.

92

Czech AIDS poster (opposite), "Live happily without fear of AIDS".

Postcards for the Terrance Higgins Trust designed by Aboud Sodano (left).

Cover and spread (below) from United Colors of Bennetton's *Colors* magazine special issue on AIDS, issue 7, June 1994. Art Director Scott Stowell, Creative Director: Tibor Kalman. Editorial Director: Oliviero Toscani.

THE SPREAD OF AIDS

Out of sight, out of mind has become a common response to aids in Europe and North America. Thanks in part to the prevalence of 'safe sex' the disease has not become the epidemic that was originally forecast in these places. The developed world has been sheltered from it by better resources but aids is nevertheless a global plague. According to the United Nations, in 1998, 33.4 million were living with hiv/aids, 5.8 million people were newly infected and 2.5 million died. Staggeringly, more than 95% of all hiv-infected people live in the developing world where a shortage of resources has made preventative and educational measures and treatment of the disease extremely difficult. In Africa, about 1.7 million young people get AIDS every year; in Asia and the Pacific the figure is 700,000.

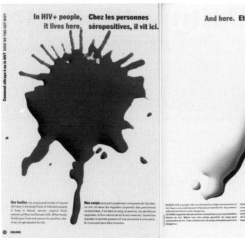

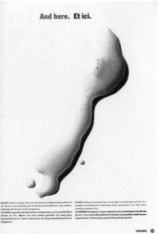

Ten million children are expected to have AIDS by the year 2000

World Health Organisation

4. Identity

Who do you think you are?

It's no surprise that the question of identity should preoccupy us. The end of the millennium was always likely to feel a bit like the longest New Year's Eve ever. In a sense, though, we have never seemed better equipped to decide who we are and where we are going. As consumers, after all, we are veterans of the identity medium. Branding, logo-making and advertising are all second-nature to us. We intuitively understand the rules of the game. We understand because we're playing the game ourselves. It isn't just retailers and manufacturers that are turning to the image makers:

For a New Labour government keen to cultivate a more creative image of contemporary Britain, the BSE plague was a disaster. British beef, long synonymous with national identity, came to be viewed as a food to be feared. When France was reluctant to accept evidence of British beef's safety the UK's tabloid newspapers took the opportunity to indulge in a spot of traditional jingoistic Eurobashing.

broadcast - divine liturgy in greek - steroids - pix - Remax Realty NOVA SCOTIA - www.a perfect ten.com - Marriott Hotel - usenet -

Football is now as much about international brands as local heroes. In Britain controversy surrounded the management of Newcastle United which was attacked for exploiting its supporters by overpricing everything from season tickets to replica shirts of star striker Alan Shearer. Nevertheless, thousands of supporters can be seen walking around Newcastle every week wearing the shirt which carries the name and number of their hero.

Pokemon walkthrough - san francisco pussy - ASian pride - 75 camaro - eyewire.com - black hardcore videos - mp3 - supraexpress

Manchester United plc produces a range of merchandise which extends well beyond the realms of football. Items such as bubble bath (left) sell by pure brand association.

The past decade has seen the rapid adoption of branding techniques among charities. First it was ribbons, beginning with the HIV/AIDS red ribbon that appeared in 1991. For its Everyman campaign to raise awareness of male cancer, the Institute of Cancer Research commissioned the Perkin (right), a small blue and orange cross designed by Sans & Baum, based on the male XY chromosome.

traditional or modern, commercially or socially motivated, we are all **maximising** our images.

Football clubs are no longer the old tribes they were. Many are budding European or even global brands that change their kit if not their identity every season. Each designer restaurant defines its appeal with an image so carefully constructed that even the ash trays are symbols. Since the original red AIDS ribbon became such a powerful marker of support, every charity now seems to have a ribbon to signify a different coloured tug on the heartstrings. In an image-saturated world, we have come to accept that every

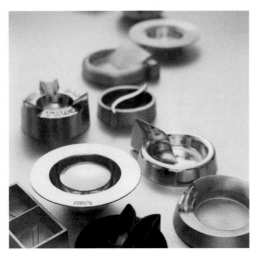

Sir Terence Conran believes in the value of brands. He built a restaurant empire in the 1990s with a string of high-profile eateries like Mezzo and Quaglino's, defined by their tailor-made design which extends right down to the ashtrays (left). More of them are stolen from the restaurants than any other item.

56i - 0 - teen gay - C for beginers - carmen electra - codes for red alert - Hyatt Acapulco - alaska backpacker shuttle - horsey's nude

Anorak	Feminist punk	Phone phreaks
Beats	Gangsta	Preppies
Celebutots	Gay street patrols	Punks
Club kids	Geeks	Queercores
Crackers	Generation X	Rainbow families
Crumblies	Green teens	Riot grrrls
Crusties	Guerrilla girls	Sex-positive
Culture babes	Hasbians	Feminists
CyberPunk	Himbos	Skinheads
Dad rockers	Hippie parents	Technoshaman
Deadheads	Lesbian avengers	Trainspotters
Digerati	Modern primitive	Travellers
Dinkys	Neo-luddites	Trustafarians
Eco-warriors	Nerds	Tweakers
Eurotrash	New age	Wasps
Extropians	Nimbys	Yardies
Fat Grrrls	Parachute kids	Zippies

saleable idea must have a powerful, adaptable, consistent identity to go with it.

Our grasp of branding rules has become so sophisticated that specialists in global image-making now feel increasingly confident about upping the ante. They are taking the commercial game up to another level of complexity and risk, in the knowledge that the rewards will be proportionately greater. Think for example of the growth of 'diffusion' – extending the prestige associated with one label to sell another product. Once it was confined to the Calvin Kleins of this world. Now everyone seems to be having a go at pushing ⫸

The Longaberger company, a $700 million direct sales organisation is certain of what it stands for. The company signals its status as the biggest maker of handmade baskets in the United States with a headquarters building (left) in Newark, Ohio, in the shape of one of its best-selling products, the Market basket. The basket is also registered as a company trademark.

male - Britney Spears naked - computer jokes - j. Harris - chevy trucks for sale - hawthorne and productivity - koi - java tutorial -

Pure genius, It could be you, The cream of Manchester, Think different, Just do it, You need it because you're weak, Because life's complicated enough, You're amazing: we want you to stay that way, Vorsprung durch Technik, It's good to talk, Because size matters, The fourth emergency service, Making life taste better, The world's favourite airline, Surprisingly ordinary prices, Every little helps, Because I'm worth it, Have a break, Let's make things better, Where do you want to go today?

"We shape the things we build, thereafter they shape us™ *"*

TM

Caterpillar, well-established as a maker of heavy plant machinery, has found extraordinary success with the extension of its brand to outdoor clothing for an urban generation (previous pages).

the boundaries. In the 1990s, Land Rover cashed in on its image to launch a pushchair for outdoor types; tractor maker Caterpillar prospered with a rough, tough 'walking machines' fashion brand. Now TAG Maclaren – already combining the values of Formula One cars and luxury action watches – has diversified into audio systems designed to compete with those of Bang & Olufsen.

There's a catch though. While few of us will have much difficulty in adjusting to the changing complexities of global branding – in fact we may enjoy the challenge – we've still got our doubts about globalism. It's one thing recognising that

More and more companies are playing on our grasp of modern image-making by pushing the boundaries of their brands. TAG Maclaren already combines luxury watches with Formula One motor racing. Now it is launching an audio brand that exploits the company's reputation for style and high technology (right). Designed by Peter Stevens, creator of the Maclaren road car, the sculptural form and composite materials of the F1 AvantGarde speakers add up to the "perfect speaker enclosure" according to the company. Each pair costs a cool £14,000.

Thanks to US marketing techniques, the 1990s witnessed the cappuccino revolution in Britain and America. With the introduction of easy-to-carry cardboard packaging, cafés and tea rooms were replaced in every city by coffee bars serving espresso, cappuccino and caffè latte made from freshly roasted beans. It was Starbucks (below) which expanded most aggressively, buying out Britain's own Seattle Coffee Company (left). Meanwhile, McDonalds made a late play for market share with its acquisition of Aroma.

Starbucks coffee is now a "brand demonstrably more valuable than Nescafé", as one business guru has admiringly put it, but that doesn't mean we necessarily find the opening of a new Starbucks outlet at the bottom of the street something to celebrate. We may secretly harbour ambitions to set up our own global business or fortune-making Internet site, yet we resent the homogenising forces of McDonaldisation. Understandly so, for the same economic forces that are making our lives the same are also having precisely the opposite effect.

Ours is by necessity the most individualistic of eras. Many

(Gary Hamel, *Design* magazine, Winter 1998-99)

103

of us have increasingly had to make our own way in a world in which career paths and roles are fluid, in which jobs for life are a thing of the past and which is more insecure than ever. Forced into being self-starters we are also learning to become a generation of self determinists. If we have to do things on our own then we've decided we're going to do things our own way.

Assuming we have the money to spend we're not going to buy that sensible Ford Sierra because it will last longer or do up Granny's hand-me-down sofa because it will last us a lifetime. We want the products in our lives that express the

Nokia's 'X-press On' interchangeable telephone covers offer buyers the prospect of different personalities for a mobile telephone to match the owner's moods. The wide range of covers on offer does not extend to the "fun" animals featured in Nokia's advertising campaign (above).

If mobile phones help define our identity, it is still clothes which offer the clearest representations of our identity. Brands such as Tommy Hilfiger (right).

tommy
the real american fragrance

chat - grenada - yankee youth jackets - scream uk - floating* - cradle of filth - ginuwine pony mp3 - french b - xxx dvd - dave matthews

Adel Rootstein's fashion mannequins
are sculpted from life every season and
manufactured in a west London factory,
their physical changes reflecting shifts
in public attitudes to the body as well as
seasonal shifts in fashion. The sylph-like
Jodie Kidd was Rootstein's skinny big
seller of 1999.

The result of an exercise carried out with the **BBC**, **IDEO**'s digital radio (right) can be set to respond to the varying listening habits of different family members. In addition, it offers text such as latest sports scores or recipes to accompany radio programmes.

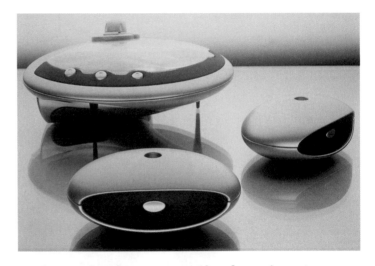

way we feel about ourselves. And we want the freedom to change them if we start feeling different.

The things that surround us – especially the technology – reinforce this independent state of mind. Once we had only street addresses and phone numbers. Today we define our individuality in all sorts of new media. We may have an email address, a mobile phone number, a pager, and both the content of this modern digital technology and the forms it takes gives us self-expression on our own distinct and personal terms.

Products can increasingly be designed around needs and

When, in today's era of digital communication, one McLuhanite future watcher announces that "the era of television, of mass created meaning, is over" we can easily grasp what he means.*

*Derrick van der Kerckore

tastes. Computers, now available in expressive shapes and colours, allow us to design our own TYPEFACES, to publish our own BOOK or to record hit ALBUMS in our back bedrooms. And the pace of techno-individualisation that fuels this DIY culture is continuing to gather on an almost daily basis.

We've already taken enthusiastically to the idea of creating our own personal Websites. Soon technological convergence will give us radio and TV soft and hardware catering for the specific needs of individual viewers and listeners.

As the forces of individualisation give us more and more power to express ourselves so our sense of ourselves has

PERSONAL BRANDING

In an era marked by an explosion in consumer choice, branding has become the most powerful weapon in the retailer's armoury.

If successful, branding can surpass the bounds of the original product and use its suggestive power to persuade us to buy often totally unrelated goods. We are all now used to the fact that as well as jeans or jumpers, perfume is sold as a low-cost passport into the glamorous worlds of Calvin Klein or Ralph Lauren.

But there have been signs that this kind of branding could become a victim of its own success. Global brands have often bulldozed the subtleties created by particulars like place or national sense of humour. Increasingly, companies are attempting to sell goods by creating the impression that their customers are being spoken to as individuals.

This 'community' approach is a key tool in the ongoing marketing of sandwich chain, Pret a Manger. One of the first to use this new-style branding, Pret's owner Julian Metcalfe still has his name and contact details printed on every sandwich bag. Consumers are invited to make suggestions for new sandwich fillings or register complaints. The sense that there is a real person behind the product increases the intimacy of our relationship to the brand.

The London-based Fresh Trading Company deploys an even greater degree of 'personal touch' to sell its product, 'Innocent' (fresh-fruit smoothies supplied to the burgeoning juice bar business). The company's brand is conceived to reflect a "natural, unadulterated image of the product", and in a reversal of a more conventional approach to branding, focuses on the product rather than on explicitly aspirational values.

The company's bottles, carry a doodle of a face and halo, and also feature textual quips. The standard reminder that 'Separation will sometimes occur*', is paired with an aside : '*but Mummy still loves Daddy'.

'Ben & Jerry's'ice-cream began life as a distinctively personal brand, owing much of its world-wide success and credibility to its image as the creation of two laid-back guys from New England. The challenge facing these companies is the degree to which personal branding can be sustained when market share increases.

107

...nt research shows ...the UK public now trusts brands like Coca Cola, Kelloggs and Nescafé more than they do the police or church."

Colors magazine, December 1998

become increasingly tied up in the things that we own. Naturally then, we're becoming more difficult to please. The problems posed by dealing with such a sceptical generation would seem to add up to a nasty dilemma for the brand giants. But not surprisingly, they are adjusting.

The popular explosion of personal brands – from Ben & Jerry's ice cream to Jonathan Crisps – underlines our continuing resistance to the forces of monopoly and homogenisation. Financial service companies court us with subtle feelgood lifestyle brands like B2. Mobile phone company Orange, self-proclaimed brand of the 1990s, gives

Using a series of blindingly simple advertisements (above and right), Orange has established itself as the largest mobile phone provider in Britain. Its appeal is emotional as well as rational, focusing on people and their need to communicate in a clear and straightforward way but, brand consultants Wolff Olins argue, also allowing the company "to own a colour" that expresses "warmth, friendliness and energy". The approach has set a trend, with friendly brands popping up everywhere. Financial services companies B2 (left), and internet credit cards Smile and Marbles, are typical.

wrongful termination - witness protection programs - poker. - "home delivery network" - Seiken Densetsu Class Change - rugby

ABSOLUT HIRST.

The designs for Harvey Nichols' food range (far left) are so vivid, tactile and seductive that you might be tempted to start a collection of the packaging rather than eating the food inside.

During the 1990s the Swedish company, Absolut has ceased to present itself as a distiller of alcoholic drinks and has instead become a commissioner of contemporary art, its advertisements (left) acting as a showcase for assorted re-workings of the distinctive bottle by a roster of artists including Damien Hirst.

telecom customers part ownership of a colour and makes them reassuring promises.

Harvey Nichols turns its packaging into collectibles; Absolut Vodka makes art instead of advertising. Even the RAC and the Dutch police go out of their way to look smart rather than officious. In every case, the message has one thing in common. You don't have to be the same. We understand – YOU'RE DIFFERENT.

Against this backdrop, traditional national loyalties might seem irrelevant. But it hasn't worked out that way at all. It is not only the reborn Eastern European and Asian states that

Offering you a "Safe and optimistic route into an uncertain future"

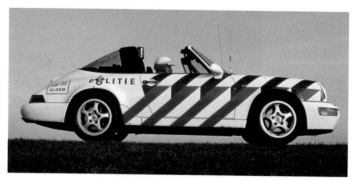

Designed in 1993 by Studio Dumbar, the Dutch police identity (left) avoided militarism in an attempt to present a more approachable face for the force. Initially it caused a stir even in liberal Holland.

The Royal Automobile Club (opposite) has also ditched a traditional image. The slick modern look of the RAC's uniform and identity was intended to drag the organisation into the 21st century.

When designs for the Euro banknote (left) were unveiled in 1997 their blandness and anonymity exposed the absence of a European identity that anyone could sign up to. Wolff Olin's Claudia Schiffer postage stamp was part of a blueprint the company created for the 'new Germany'. The identity replaces the black of the German flag with European blue. Schiffer's international fame makes her the perfect cultural ambassador for a nation, while her nakedness is intended to symbolise the wholesome, honest approach of the German people. "Creating a global brand for Germany is not a peripheral concern of domestic politics; it is the most important issue facing the country today," argue Wolff Olins.

are crying out for recognition of their individuality, and traditions in the form of new currencies, flags, stamps. Even for established nations, image makeovers were all the rage in the run up to the millennium, with the branding specialists carefully stirring the nationalist pots in places like Germany and the UK.

In cosy old Britain indeed, nationalism and regionalism are much higher on the agenda than before. Few things got people more steamed up in the late 1990s than a good argument about the flag. Threaten to interfere with the Union Jack – as the British Tourist Authority was rumoured to be

It was not only Tony Blair's government that indulged in promoting British culture as an exportable commodity. The music industry (and its media) promoted the export of culture by pushing Britpop (below) as well as the 'Brit' Awards for music.

The British royal family is always at the centre of discussions about national identity: even the Queen Mother (far right) was used in a recent project aiming to 're-brand' Britain.

The image of Diana, Princess of Wales, (often in heavily airbrushed forms) is perhaps the only one which is too powerful to be used in conjunction with the British flag. It has become an international brand in its own right.

"marketing Britain like soap powder" Daily Mail, 1997

contemplating – and the full wrath of the traditionalists descends. Propose a campaign to renew Britain's creative identity – as Tony Blair did in backing Britain™ – and you find national dailies on the attack.

The notion of national identity is already eroding when it comes to buying anything from cars to toys: either companies have become multinational conglomerates whose product identities are difficult to pin down to one nation, or buyers of, say, Nintendo or Sega computer games, simply don't care which country products come from. Yet when the Conservative ex-Prime Minister Margaret Thatcher

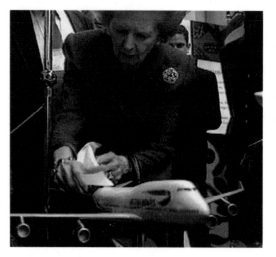

British Airways' new identity featured a collection of tailfin designs created by artists from all over the world and was meant to emphasise the company's versatile global strengths. But the decision to drop the Union Jack was unpopular with those who perceived its removal to be unpatriotic. Nationalistic flag flier Baroness Thatcher expressed her disapproval of the identity by tying a handkerchief around the tail.

shows her disapproval of British Airways' dispensing with its Union Jack heritage by censoring the tail design of one of the company's model aeroplanes with a knotted handkerchief, it hits the front pages.

It might seem curious that a generation accustomed to the new realities and future imperatives of modern life should still feel the urge to wrap itself in national flags today. As experienced critics of branding bullshit, we could be forgiven for concluding that such symbols are hopelessly heritage-laden and old-fashioned. But there is more to this impulse than our need to find something reassuring and stable to fall ⤞

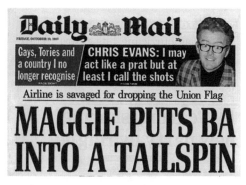

Daily Mail

FRIDAY, OCTOBER 10, 1997 35p

Gays, Tories and a country I no longer recognise / CHRIS EVANS: I may act like a prat but at least I call the shots

Airline is savaged for dropping the Union Flag

MAGGIE PUTS BA INTO A TAILSPIN

"We fly the British flag, not those awful things you put on the tails." Margaret Thatcher, 9 October 1997

114

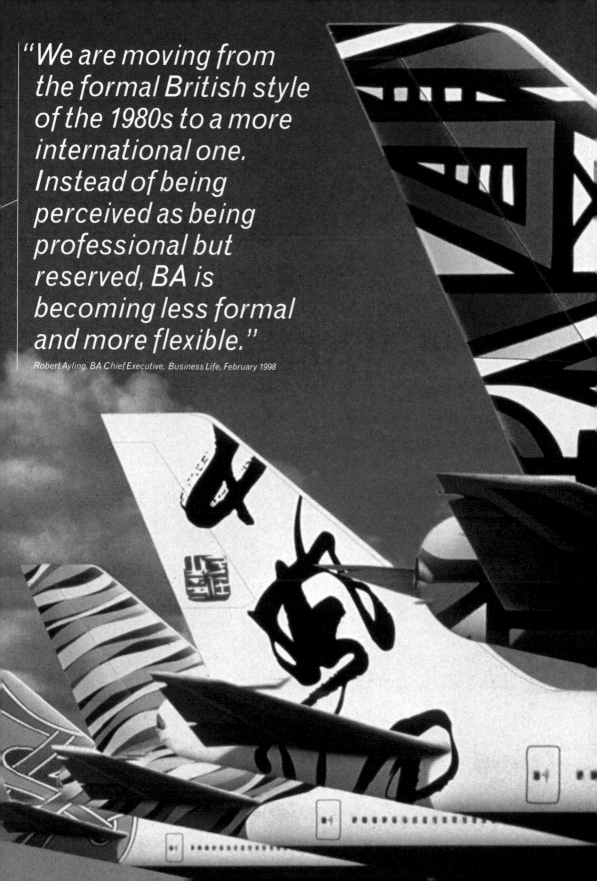

"We are moving from the formal British style of the 1980s to a more international one. Instead of being perceived as being professional but reserved, BA is becoming less formal and more flexible."

Robert Ayling, BA Chief Executive, Business Life, February 1998

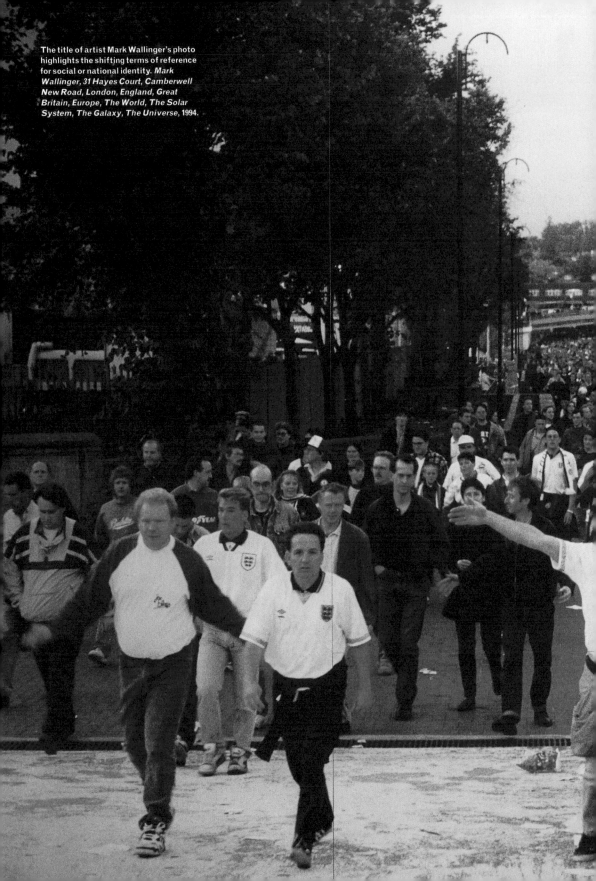

The title of artist Mark Wallinger's photo highlights the shifting terms of reference for social or national identity. *Mark Wallinger, 31 Hayes Court, Camberwell New Road, London, England, Great Britain, Europe, The World, The Solar System, The Galaxy, The Universe*, 1994.

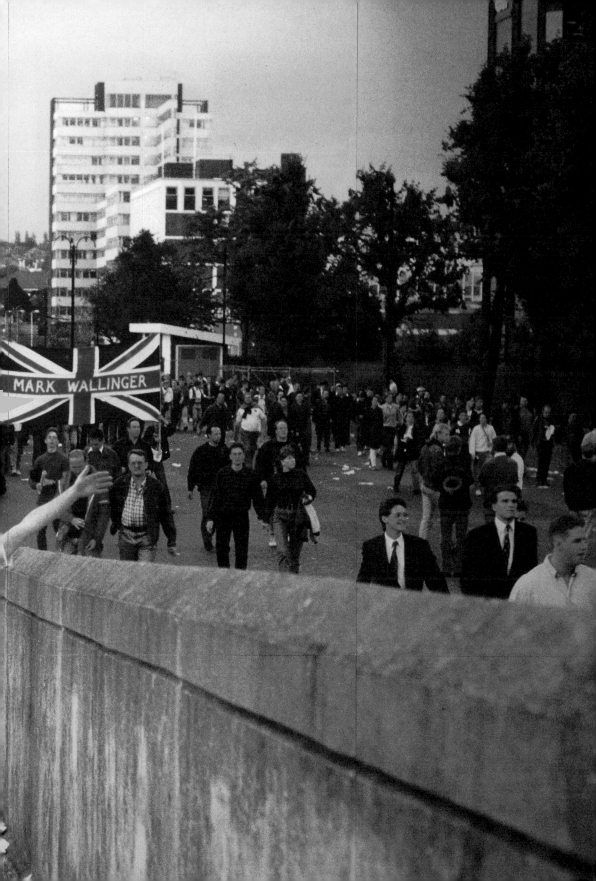

back on amidst the collapse of old certainties that the end of the millennium brought in its wake.

On the face of it, the forces of mass marketing and individualism may seem increasingly incompatible. But expertise in brand management will produce innovative ways to bridge the gap. We are learning to adjust to living in an era in which the lines between our roles as individuals, citizens and customers seem increasingly blurred. Whether it's through allegiance to a country, a football team, or a particular sort of home-made music, our right to express our identity remains as sacred now as it always has been.

Sophisticated identities are not the exclusive territory of multinational corporations. Even in the supposedly counter-cultural world of popular music, bands like Fat Boy Slim, Jamiroquai and Blur have their own logos (above), while the Spice Girls (right) turned brand management into international big business.

One of the most successful nightclubs in recent British history is the Ministry of Sound (opposite), a club whose brand identity is applied liberally to everything it touches – from records to clothes, even to its own magazine.

118

5. Crisis

Artists are increasingly borrowing the language of design. Lucy Orta's 'Habitent' (below) is one of a series of works made using the language and materials of outdoor equipment and clothing. Orta's nomadic sculptures explore the modern meaning of home, personal space and the individual fight for survival in hostile conditions.

The Final Home teddy bear (opposite) is the accessory of choice for the alienated 21st century baby. The Final Home survival label (left) appears in all of the clothing.

The designers of the 'Millennium Bug' logo (right) were faced with the problem of creating a symbol to represent a phenomenon which has no visual form.

The shape of uncertainty

As well as reflecting contemporary concerns, you'd rather expect the products of our time to express our hopes for the future. After all, to modernist designers of the 1930s a tubular metal chair seemed to represent nothing less than the future progress of humanity. Even in the 1960s, products which dreamily blended pop influences and hi-tech imagery reflected the optimism of the Space Age. By comparison, seen through the images and objects that make up the contemporary world, our future is an altogether darker and more confusing place.

CRISIS FASHION
Increasingly, the clothes we buy are responding to an urge to construct both individually-tailored and flexible identities. Over the last few years, fashion designers have produced collections which exaggerate this trend.
Final Home is the concept of designer Kosuke Tsumura, with a focus on clothing which is able to transform the wearer. The first Final Home collection in 1994 included a coat inspired by the designer's experience of once having to sleep in the open, which enabled its wearer to stuff the garment's 48 pockets with newspaper. Tsumura's more recent designs retain an interest in flexibility, but also use the idea of the city as a template, looking at themes of urban identity and survival. With his highly-padded 'Mother' coat (overleaf), Tsumura offers a cocooned environment for both mother and baby, their faces made anonymous by a large shared hood. Tsumura also supplies his 'urban warrior' with an 'AK 415' life-size nylon gun, complete with shoulder strap. This piece is part of his 'CIA Series' (1999), a collection which features camouflage material, hidden pockets to carry concealed objects, and balaclava hoods – very useful for protecting against the invasion of personal privacy.

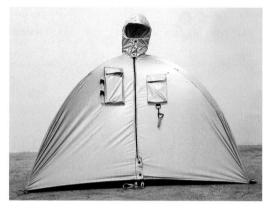

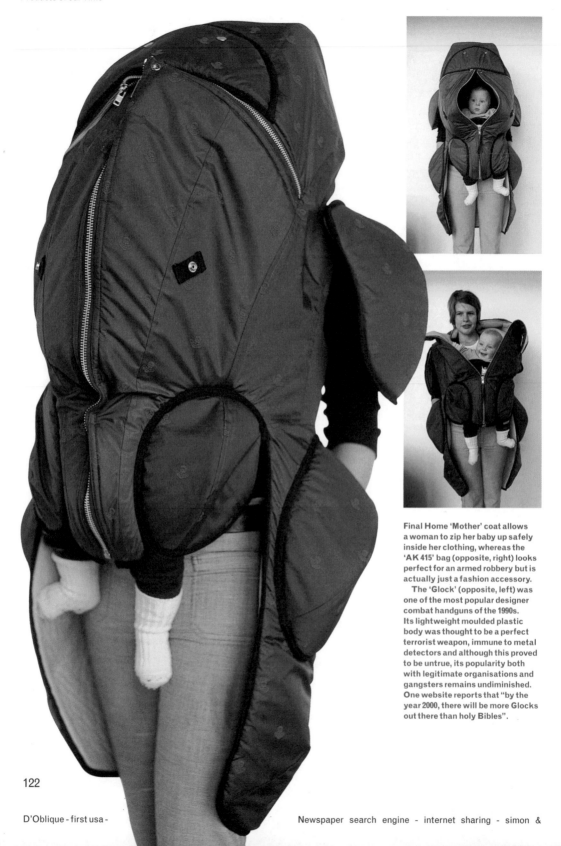

Final Home 'Mother' coat allows a woman to zip her baby up safely inside her clothing, whereas the 'AK 415' bag (opposite, right) looks perfect for an armed robbery but is actually just a fashion accessory.

The 'Glock' (opposite, left) was one of the most popular designer combat handguns of the 1990s. Its lightweight moulded plastic body was thought to be a perfect terrorist weapon, immune to metal detectors and although this proved to be untrue, its popularity both with legitimate organisations and gangsters remains undiminished. One website reports that "by the year 2000, there will be more Glocks out there than holy Bibles".

"It's as if the future has been shrinking one year, per year, for my entire life... 2005 is still too far away to plan for and 2030 is too far away to even think about."

Danny Hillis, *Wired* magazine, 1995

The apocalyptic bleakness of so much millennial imagery – from Y2K logos to *Armageddon* film posters – provides telling clues about our apprehensive state of mind. Nowadays we lack little in technological expertise, education or discrimination, we have choice in abundance and more technology-driven control over our environment than ever. Yet for all our skills and capabilities, we are less and less certain of our ability to create the secure future we once imagined for ourselves.

To add to our anxieties, the accelerated pace of the world and the rate of change make it difficult to envisage

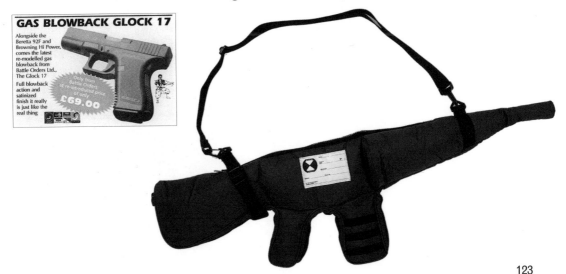

THE WORLD TRADE CENTER

- nude photos - "gay foot fetish" - leix - free sex - "arnold schwarzenegger" - Real Audio titanic - Age of empires 2 - visitenkarten

'Souvenirs for the End of the Century' includes six pewter 'Buildings of Disaster': the Unabomber's cabin (below right), the Texas School Book Depository, Chernobyl nuclear power plant, the World Trade Center (opposite), the Watergate building (below) and the Oklahoma City Federal building (right).

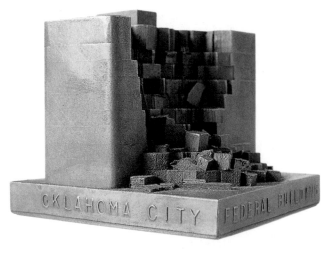

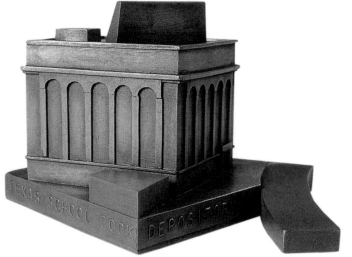

CONSTANTIN BOYM

To some, the objects turned out by the New York studio of designer Constantin Boym may look more like recycled debris than 'proper' products. What, you might wonder, are we to make of an 'American Plumbing vase' consisting of standard sections of plastic pipe, or a clock made from a tuna can, or a stainless steel storage container (commissioned by Alessi) moulded in the form of a soup tin stripped of its label?

Boym would be happy if you were to question the meaning and validity of his work. Ever since he set up his studio in

1987, the Russian-born designer's ambition has been to break down stereotypical visions of design as something separate from popular culture. But Boym is more than a polemicist who has turned the techniques of the Dadaists to his own ends. His intention is to get people to look at the design of everyday things with new eyes: "Our goal is to expand understanding of design as an inclusive, diversified and populist activity," he says. "We are driven by the belief that beauty lies unnoticed in the ordinary and it is the designer's duty to bring it out."

It is a measure of the new acceptability of design's counter-culture that Boym is making the transition from the avant-garde into the mass market. His studio has worked not just for Alessi but for the German plastic specialist Authentics, for whom Boym has created plastic containers modelled on Tupperware and metal kitchen utensils based on old American designs.

But despite these cross-over commissions Boym hasn't abandoned his principles, or an enduring enthusiasm for producing idiosyncratic work. His latest project is a catalogue of

'Souvenirs of the End of the Century'. This unsettling collection already features more than 30 designs, through 'Missing Monuments' and mini-busts of 'Fathers of Modern Art' – naturally including Duchamp – to six 'Buildings of Disaster' which include the Unabomber's cabin and the Texas School Book Depository, made famous on the day of Kennedy's assassination. Constantin Boym explains that the goal of this three year project " to be sure that objects like souvenirs, even ones that deal with tragedy and disaster, are no longer taboo in today's design."

125

what is round the next corner.

One way of dealing with a headlong rush into a world you cannot envisage is to deny that it exists at all. No wonder then that the arrival of the new millennium has brought with it the emergence of '20th century retro' as a fully-fledged heritage industry. With departments including the cosy fifties, the swinging sixties and the ghastly, gorgeous seventies, our retro supermarket has become a delightful refuge from the uncertainties of modern life. We are offered everything we need in the way of escapist fantasy at every price point: perfect replica scooters, Easy Rider-style motorbikes,

Austin Powers (above), the film character played by comedian Mike Myers, draws on the British stereotype portrayed in the James Bond films of the 1960s and 1970s. Myers' accessories include an E-Type Jaguar painted to resemble a Union Jack.

Piaggio's original 1950s Vespa design (right) regained its appeal in the 1990s, and now 45% of scooter purchases are made by teenagers.

126

Lava lamps (left) were once synonymous with the tasteless side of 1960s decor but by adding new products and 1990s cartoonish graphics to the range, Mathmos hit the jackpot. Sales rose from 10,000 in 1989 to 800,000 in 1998.

The Roberts Revival radio (right) proves that it is possible to make a selling point of an image stuck in the past. In the 1990s, the Revival, a leather-covered update of one of the company's 1950s models, projected Roberts as a retro-cool brand.

streamlined kettles and toasters, post-war twinsets, Michael Caine specs, even radios from the era when Britain led the way in stereograms.

Now we can even have our cake and eat it. Once if you wanted retro authenticity in the form of a Volkswagen Beetle you had to put up with a broken heater and a windscreen six inches from your face. Today designers are ever more expert at serving us up with the latest technology dressed up in authentic-looking period clothing. The curvaceous new Volkswagen Beetle conjures up just enough of Herbie the Love Bug to keep us happy but, as a modified VW golf, it has ≫→

"A piece of corporate heritage management to make people feel warm about the brand"

Quentin Wilson, *Top Gear*, BBC television

The new VW Beetle builds on fond
memories of the original rear-engined
Volkswagen, but utilises all the
contemporary technology of the Golf
engine and floorpan on which it is based.
It also bears a striking resemblance to
some of the recent models designed for
VW's sister company, Audi.

Shock tactics became a standard attention-seeking technique of 1990s image makers. When French Connection UK changed their name to 'fcuk' the advertising campaigns (opposite and below left) used the 'double-take' acronym in punning lines such as "fcuk fashion" and "fcuk advertising" that verge on the puerile and offensive. It is not clear what this is meant to say about the company's mainstream clothes, nor what the Young Conservatives youth arm Conservative Futures hoped to achieve by adapting the technique for their own publicity campaign, 'cfuk' (below right). This appropriation resulted in French Connection threatening the Conservatives with legal action.

The Prodigy's single 'Smack my Bitch Up', 1997 (CD cover, right) leaves no room for doubt about its intention to shock as many people as possible.

none of the disadvantages of a car that is sixty years old. In fact, it is everything that Ferdinand Porsche's original Beetle was not: sophisticated, expensive, with the engine at the front.

The retro sales pitch is a familiar one. But the more adventurous product pitches of the 1990s would be quite impossible for a visitor from the 1970s or even the 1980s to grasp. Only in the 1990s could the British clothing company French Connection have settled on the acronym fcuk as the appropriate logo and slogan for its marketing campaign; only in the 1990s would the UK Young Conservatives – recently relaunched as the cfuk (Conservative Futures UK) – have

"French Connection is an entirely non-political company that does not wish to be associated with any party." A French Connection official

inc. - danny devito - counters for web pages - cd now - mechanical low back pain - air fare - Italy's industry - Charter Schools -

fcuk advertising

french connec tion yoursel f

what the french connection

fcuk®

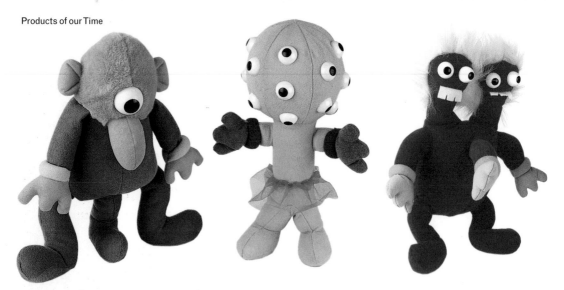

started an argument by borrowing the idea in its own, rather feeble, attempt to appeal to a new audience.

If the association with a misspelt four letter word doesn't give us much idea what either product is meant to stand for, it is not a concern that is holding back the marketers. Shock tactics are now viewed as par for the course as more and more companies take the ironic or outrageous route. It is not just about image either. Manufacturers are going out of their way to make products of every kind **unorthodox** and even **offensive**. Since adding mysterious lemon squeezers and phallic plastic gas lighters to its sensible line in bread

A selection of Alessi products (right). In the early 1990s, Philippe Starck's shiny metal 'Juicy Salif' lemon squeezer (background, right) took over from Michael Graves's whistling kettle (centre) as the most instantly recognisable of the Alessi range. At one point, the company was reported to be selling 50,000 Juicy Salifs a year. The company also introduced a range of tongue-in-cheek plastic products such as Guido Venturini's phallic 'Firebird' gas lighter (second from left). The 'Anna G' corkscrew (left) reputedly named after the wife of its designer, Alessandro Mendini, is the current best seller.

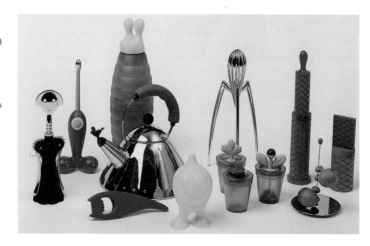

kathleen hanna - andrew lloyed webber - ksmi - carbo quick - fre - chesterfield hotel mayfair - "seventy five" - why sprint - MIME

baskets and coffee pots, for example, Alessi has made the leap into the mass market. Meanwhile the American company Rumpus has created a toy cult by specialising in collections of soft toy 'science freaks'.

If we did not respond to this approach, the media and product marketers wouldn't keep on breaking the rules. The truth is that we are drawn towards the subversive because it reflects the way we feel. Forecasting organisation Future Foundation, argues that today we are moving towards an 'I' society in which we increasingly define ourselves by what we do and how we live rather than what we earn. As the ⟫→

New York company Rumpus has made a cult of kids' toys like the 'Science Freaks'(above left and opposite), which are sold in plastic 'laboratory jars', while the latest addition to an increasingly macabre TV collection of cartoons aimed as much at adults as children is Johnny Pumpkin (above right), a veggy-headed boy who can only come out at night. Johnny's favourite toy is the Chipolata kipper wagon, a vehicle driven by the thrashing head of a dying fish.

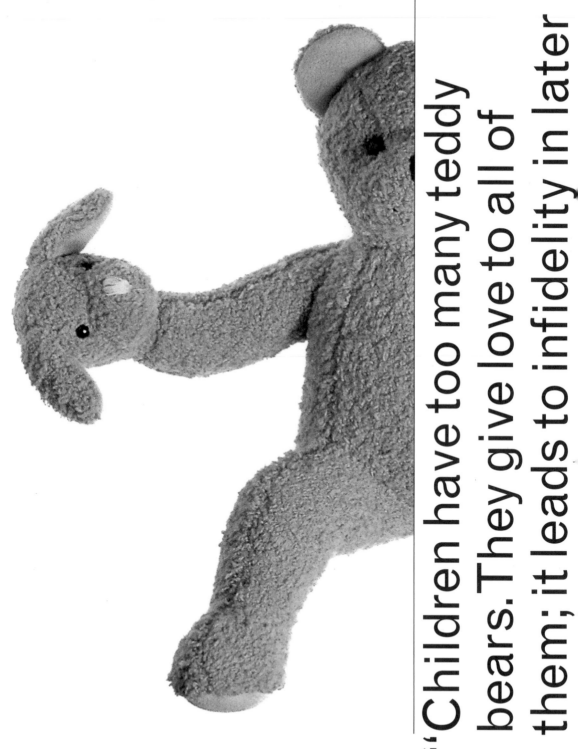

"Children have too many teddy bears. They give love to all of them; it leads to infidelity in later

Tribology - knitting patterns - tabliture - WB Popular - "Casper Van Dien", Revenant - you're my jamaica and charley pride - cute ftp -

life. With this, you learn to love differently, to love the different aspects of one person." Philippe Starck, DailyTelegraph, 1999

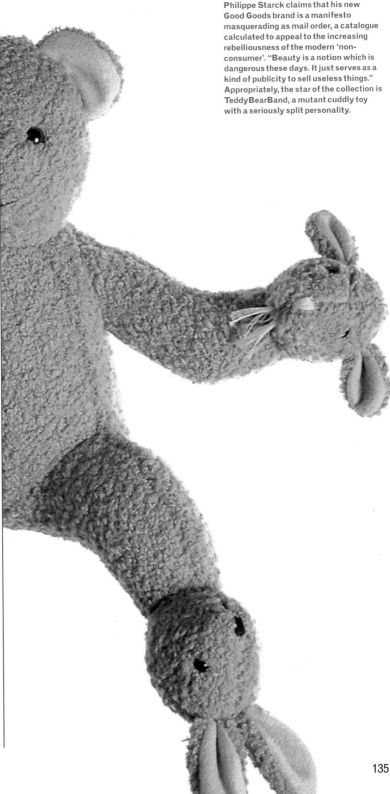

Philippe Starck claims that his new Good Goods brand is a manifesto masquerading as mail order, a catalogue calculated to appeal to the increasing rebelliousness of the modern 'non-consumer'. "Beauty is a notion which is dangerous these days. It just serves as a kind of publicity to sell useless things." Appropriately, the star of the collection is TeddyBearBand, a mutant cuddly toy with a seriously split personality.

135

alamacs - death of a salesman - uncircumcision penis pictures - derechos humanos - fureteur francais -

"People in the 'I Society' are interested in the wider impact of what they do, in what they buy and in self expression. It's about individuality,"

Melanie Howard, Director, Future Foundation, 1999

A number of graphic designers during the 1990s moved towards self-reflection and unashamed self-expression in their work. With its book entitled *Process: A Tomato Project*, (below left) the design group Tomato was the best-publicised British exponent. Across the Atlantic David Carson's design of the music magazine *Ray Gun* (below right) brought him worldwide attention.

Jonathan Barnbrook's Virus type foundry catalogue (opposite) represents an attempt by the designer to explore political issues through the process of typography.

'I' Generation, Future Foundation claims, independence, identity, interactivity and individuality are our new priorities.

Benetton, undisputed king of the 1990s subversives, is one company that understands this better than most. If you didn't know what it was selling, you would never find out from the poster campaigns that has made the organisation notorious. Benetton has not shown a product at all since 1990. Instead, the company has set about confronting its its public with in-your-face advertising images like the moment of death of an AIDS victim. *Colors*, Benetton's global magazine about "the rest of the world" reinforces the pitch. Focusing on ⫸→

underground weather el paso texas - wholesale jewelry - Escambia County Florida Wills - bloor street - BJ'S DISCOUNT

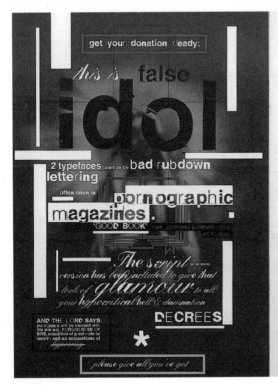

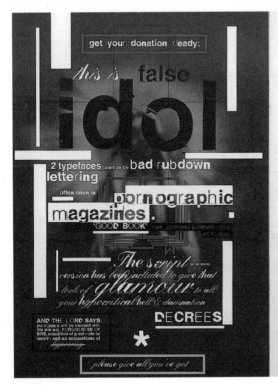

WAREHOUSE - .22 rifles - historia de la india en espa§ol - "campos magnÇticos" - waterfest +keyless - halloween fonts and clip art

"Virus is penance for your sins + virus watches you and grows with your every move + virus is a contradiction: how can something organic exist on a machine? + virus is right-wing paranoia + virus is a social stigma + virus is not responsible for its own actions + virus is the language you use to speak to others + virus is in league with the CIA + virus is a sign of the end of the millennium + virus is a small being which brings down a huge organism or organisation + virus is a crime seen on TV and copied by thousands + virus is a hated decoration that spreads over everything we see + virus is a runny rose and a sore throat + virus is a cheap ploy to sell useless typefaces for computers"

Jonathan Barnbrook, *Welcome to the Cult of Virus*, 1997

Jonathan Barnbrook revels in a
subversive approach to typography.
The manifesto (above) is the introduction
to his own catalogue of fonts, Virus.
'Apocalypso' (right), is a symbol font
created from a selection of bleak icons
of disaster and death.

SHOP UNTIL THE BOMB DROPS

BORN GUILTY

ME AND MY PROZAC

CELEBRITY STALKER

THE END

GENUINE MESSIAH

THE ILLUSION THAT YOUR COUNTRY IS SUPERIOR TO ANY OTHER

FATWAH FOR YOU

ETHNIC CLEANSING

MANUFACTURED IN A REPRESSIVE REGIME

YOUR SON WAS KILLED BY FRIENDLY FIRE
THANKS

CONGRATULATIONS ON MAKING A PROFIT FROM WAR

SCARED SLAG OFF ISLAM

RAMPANT CAPITALISM

THE ANTICHRIST AS A MEDIA PERSONALITY

CS
corporate SUFFOCATION

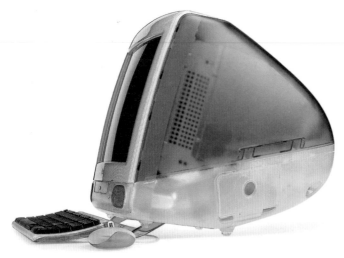

Not all contemporary brands have had to be confrontational to find success. The Apple iMac's curves (left) and range of bright colours (below) were calculated to make users treat it with the affection normally reserved for the family pet. Its sense of personality proved a winning contrast to the blandness of Microsoft culture and revived the fortunes of a flagging brand.

"universal" themes from toys to war and making maximum use of controversial imagery it is, it claims, "not only a means of communication but an expression of our times".

It's hard to know how effective this is as a sales technique. In theory, a distaste for the imagery and doubt about the motives should deter many potential Benetton customers. But catering to our individualistic nature doesn't have to mean being confrontational. Think for example of the comeback of Apple Computer. Until the launch of the iMac in mid-1997, the originator of the first true PC was considered a busted flush. Yet on the day of its launch, people camped

A MANIFESTO FOR 2000
We, the undersigned, are graphic designers, art directors and visual communicators who have been raised in a world in which the techniques and apparatus of advertising have persistently been presented to us as the most lucrative, effective and desirable use of our talents. Many design teachers and mentors promote this belief; the market rewards it; a tide of books and publications reinforces it.

Encouraged in this direction, designers then apply their skill and imagination to sell dog biscuits, designer coffee, diamonds, detergents, hair gel, cigarettes, credit cards, sneakers, butt toners, light beer and heavy-duty recreational vehicles. Commercial work has always paid the bills, but many graphic designers have now let it become, in large measure, what graphic designers do. This, in turn, is how the world perceives design. The profession's time and energy is used up manufacturing demand for things that are inessential at best.

Many of us have grown increasingly uncomfortable with this view of design.

Designers who devote their efforts primarily to advertising, marketing and brand development are supporting, and implicitly endorsing, a mental environment so saturated with commercial messages that it is changing the very way citizen-consumers speak, think, feel, respond and interact. To some extent we are all helping draft a reductive and immeasurably harmful code of public discourse.

There are pursuits more worthy of our problem-solving skills. Unprecedented environmental, social and cultural crises demand our attention. Many cultural interventions, social marketing campaigns, book, magazines, exhibitions, educational tools, television programmes, films, charitable causes and other information design projects urgently require our expertise and help.

We propose a reversal of priorities in favour of more useful, lasting and democratic forms of communication – a mindshift away from product marketing and toward the exploration and production of a new kind of meaning. The scope of debate is shrinking; it must expand. Consumerism is

- Philosophy of love - 1965 education statistics - colorize - PC 104 - Warez - voyager internet - American prehistory - prader willy

NO SHOP
INTERNATIONAL NO SHOP DAY!
BUY LESS, LIVE MORE, RELAX!
131 LOWER MARSH LONDON SE1
DATE: 29/11/97

DON'T SHOP THE PLANET
EVERY PRODUCT WE BUY 0.00
IMPACTS ON OUR ENVIRON- 0.00
MENT: RAW MATERIALS ARE 0.00
EXTRACTED, ENERGY AND 0.00
RESOURCES GO INTO 0.00
MANUFACTURING, AND 0.00
FINALLY, WHEN IT IS NO 0.00
LONGER WANTED, WE HAVE TO 0.00
FIND A PLACE TO DUMP IT. 0.00

TOTAL: PHONE
CREDIT: 0171 490 1555
CHANGE DUE: THOMAS/MATTHEWS
 DEFINITELY!

*IN COLLABORATION WITH THE
ROYAL COLLEGE OF ART
ENVIRONMENT PROGRAMME

Benetton's artistic director Oliviero
Toscani has been responsible for some
of the most memorable and controversial
advertising images of the decade (below
and overleaf). Part of their shock value
derives from the fact that the images
of birth, war and death seem to bear no
relation to the middle-market clothing
whose brand they promote. Instead,
Toscani has used the advertising
medium to raise awareness of political
and social issues.

Design has begun to stir from its
apolitical slumbers in the 1990s. Created
by Kristine Matthews and Sophie
Thomas, No Shop was a London
installation featuring empty shelves,
empty cash registers and till receipts with
anti-consumerist slogans (left) that
celebrated International No Shop day.

outside American computer stores to be first in the queue.
The iMac was a smash hit not because of innovative
technology – it had little that was new. The key was that
with one friendly-looking product, Apple restored its image
as the computer for people who "think different".

In our mass-produced world, we are crying out for
difference, for a culture which reflects our individuality.
And while it may sometimes seem that the global market we
inhabit is the irresistible force that shapes our future selves,
we should not underestimate our influence in shaping the
world and its products into the form we want them to take.

running uncontested; it
must be challenged by other
perspectives expressed,
in part, through the visual
languages and resources
of design.
 In 1964, 22 visual
communicators signed the
original call for our skills to be
put to worthwhile use. With
the explosive growth of global
commercial culture, their
message has only grown more
urgent. Today, we renew their
manifesto in expectation that
no more decades will pass
before it is taken to heart.
*First Things First 2000, a fin
de siècle reprise of a design
manifesto first published 35
years ago.*

UNITED COLORS
OF BENETTON.

snydrome - sleepy fetish - 1960s Comic Book Characters and alternative - nfl power and the glory - BLACK ICE firewall - teen tits -

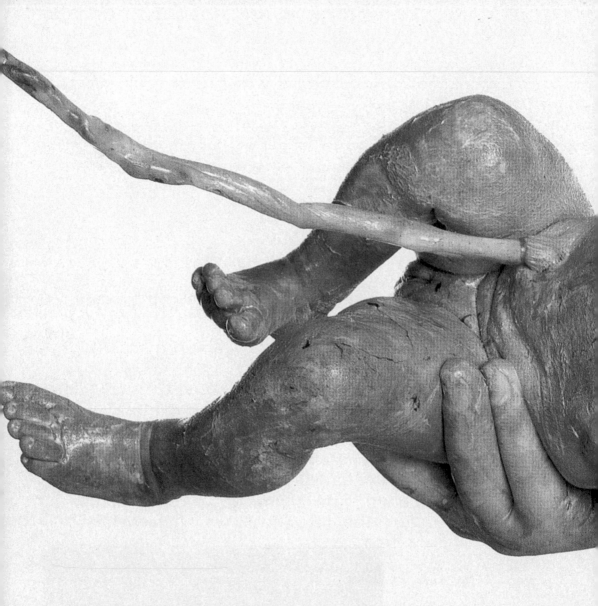

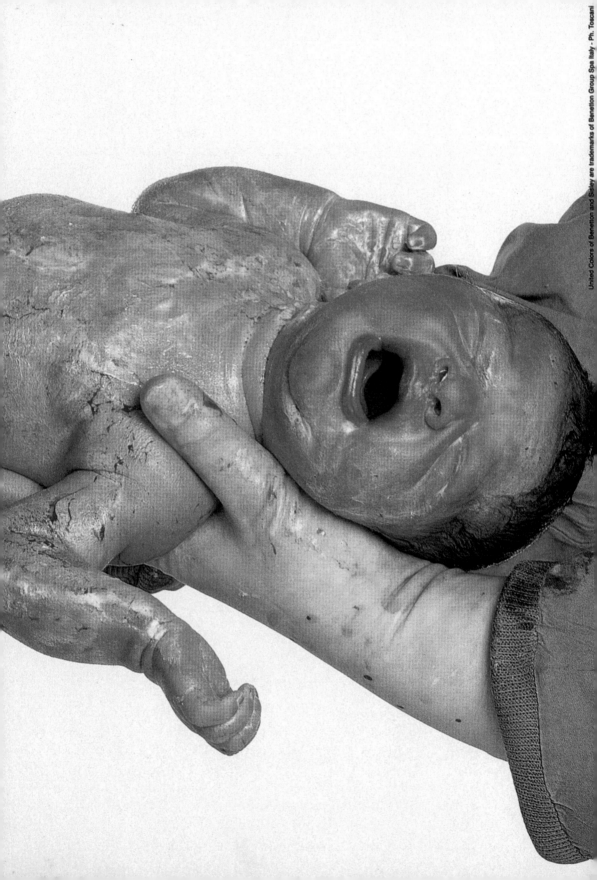

Photography credits

Nigel Jackson: pp.29, 33, 34, 48,49,50, 60 (bottom), 73 (top), 78 (bottom left), 80 (bottom), 89, 91, 95, 96, 97 (top left), 107,121, 123, 132 (top), 133 (left). Elisabeth Scheder-Bieschin: pp.28, 36, 122

Inside Covers: Traders in the Short Sterling Futures Pit at LIFFE reacting to Gordon Brown's budget, 1997. Ashley Coombes/News International Syndication. p.4-5: Baby on conveyor belt photo J. J. Waller. p.6: Action Man. Nigel Jackson. p.9: condom photo Andrew Penketh. p.12: Photograph of John Major MP courtesy of PA News. p.15: Loft set by kind permission of the Trustees of the Geffrye Museum. p.19: photos by Mark Borthwick, courtesy of Maison Martin Margiela. p.22, 23: photos by Hans van der Mars, courtesy of Droog Design. p.30: Alarm Clock Table photo by David Spero. p.32: Markus Richter, courtesy of Authentics Artipresent. p.38,39: photos by Todd Eberle. p.42: shopping taxi image courtesy of Studio Myerscough. p.54: courtesy of Autocar. p.55: courtesy of PDD Ltd. p.56-57: courtesy of Frank O. Gehry Associates. p.59: photo by Edmund Clark p.61: courtesy of ICE Ergonomics. p.62: courtesy

of Priestman Goode. p.63: photo Roddy Field/Roslin Institute. p.68-69: courtesy of Lucozade Energy. p.64: courtesy of Deepend Design Ltd/The British Council. p.70-71: courtesy of illusion2k. p.78: TV licence ad image courtesy of Rapier Ltd. p.78 plastic dress photo by Chris Moore, courtesy of Hussein Chalayan. p.79: courtesy of Vexed Generation. p.80-81: infant simulators courtesy of Baby Think It Over. p.82: femidom poster image courtesy of Jonathan Barnbrook. p.83: viagra image courtesy of Pfizer, ecstasy photo by Dean Chalkley, mouse with ear photo courtesy of BBC Photo Library. p.86-87: photo by Sichov, courtesy of Rex Features/Sipa Press. p.88 Aimee Mullins for *Dazed and Confused*, photo: Nick Knight, Art Director: Alexander McQueen. p.92, 93: AIDS posters courtesy of Terrence Higgins Trust. p.97: Perkin photo by Anthony Oliver. p.97: ashtrays courtesy of Conran Design Partnership. p.98: reproduced by permission of The Longaberger Company ®, The Longaberger Company Home Office Building in Newark, Ohio, is a trademark of The Longaberger Company, ©1997 The Longaberger Company. p.100-101: photos

by Stefan Ruiz from a publication designed by FUEL. p.103: Seattle Coffee Company image courtesy of David Pocknell. p.105: courtesy of Adel Rootstein. p.106: courtesy of IDEO. p.108: courtesy of The Partners/B2. p.109: courtesy of Orange. p.110: Harvey Nichols food packaging courtesy of Michael Nash Associates, Absolut Hirst image courtesy of the artist/The Absolut Company, Dutch police identity courtesy of Studio Dumbar. p.111: RAC identity courtesy of North. p.112: Euro notes photo by Anthony Oliver. p.112 Neue Deutschland image courtesy of Wolff Olins. p.113 Re-branding Britain image courtesy of Wolff Olins. p.114: courtesy of ITN. p.115: BA identity designed by Interbrand Newell & Sorrell. p.116-117: courtesy of the artist/Anthony Reynolds Gallery. p.120: courtesy of Lucy Orta. p.133: courtesy of Simon Henwood/Seven. p.137-139: courtesy of Jonathan Barnbrook. p.141-143: courtesy of Oliviero Toscani.

144